A–Z

OF

CAMBRIDGE

PLACES - PEOPLE - HISTORY

Sarah E. Doig

Photographs by Tony Scheuregger

AMBERLEY

First published 2019

Amberley Publishing
The Hill, Stroud, Gloucestershire, GL5 4EP
www.amberley-books.com

Copyright © Sarah E. Doig, 2019

ISBN 978 1 4456 8115 3 (print)
ISBN 978 1 4456 8116 0 (ebook)

British Library Cataloguing in Publication Data.
A catalogue record for this book is available
from the British Library.

Typesetting by Aura Technology and Software
Services, India. Printed in Great Britain.

Contents

Introduction

More tourists flock to Cambridge than almost anywhere else in the United Kingdom. It is easy, therefore, to view the city as some sort of theme park where, 365 days of the year, hundreds of camera lenses are trained on every nook and cranny. Instead, it is a place where people live, work and study alongside one another, much as they have done for many centuries. Cambridge, therefore, has a rather more mundane story to tell than that which the impressive gatehouses, spires, chapels, courtyards and towers suggest.

There are, of course, a plethora of academic books in print which detail the history of the city of Cambridge, as well as the university and its colleges. This book is not one of them! Instead, I like to view my *A–Z of Cambridge* as an alternative local history guide. It is, however, based on fact and draws on a range of reliable sources of information. In my book, I have attempted to strike a balance between town and gown, and I have tried to ensure that a visitor to the city does not have to pay too many entrance fees to view the places I write about. You will also notice the quirky chapter headings, designed to encourage the reader to dip into the book and, there, to learn something surprising, funny or just simply interesting about Cambridge, its history and its former residents.

A

Alms

Signs of wealth are everywhere you turn in the city of Cambridge. This is especially true when we look at the numerous grand college buildings. Nevertheless, even in the early days of the university, the well-to-do were mindful of the need to help the poor. This was achieved by either founding an institution in which those in need could be housed, fed and clothed, or by leaving a legacy on death to an existing foundation or charity. However, such benefactors were not necessarily just motivated by kind-heartedness: it was believed that giving to the poor offered the promise of a reward in heaven. As a result, Cambridge benefitted from several almshouses being founded in the second half of the fifteenth century, many allied to a particular college.

Queens' College almshouses were founded by the president of the college, Andrew Dockett, who made provision in his will of 1485 to support three poor women. The almshouses once stood in present-day Silver Street, and in 1676 housed eight almswomen due to later legacies from Dockett's successors. Similarly, the Caius College almshouses were founded by Richard Ely in around 1475 to house three poor people appointed by the college.

Not all Cambridge almshouses were linked to the university. In the late fifteenth century, Thomas Jackenett provided money for the construction of four almshouses for poor men and women of the parish of St Mary the Great. An upper floor built over the accommodation was let out to provide an income with which to support the residents and to pay for repairs to the building. He also stipulated that once a year, he and his wife 'and all faithful Christians deceased' be commemorated at Great St Mary's Church. Although Jackenett's original almshouses have long since disappeared, its modern-day successor stands in King Street.

King Street is also home to the Knight and Mortlock almshouses. These five units of accommodation are named after the original benefactors. In 1640, Elizabeth Knight left provision in her will which, augmented by other legacies, allowed for the building of almshouses for two widows and four spinsters. The original building was replaced in 1818 by William Mortlock, and then in the 1880s, the almshouses moved to their present location where they are still in use today. They are now administered

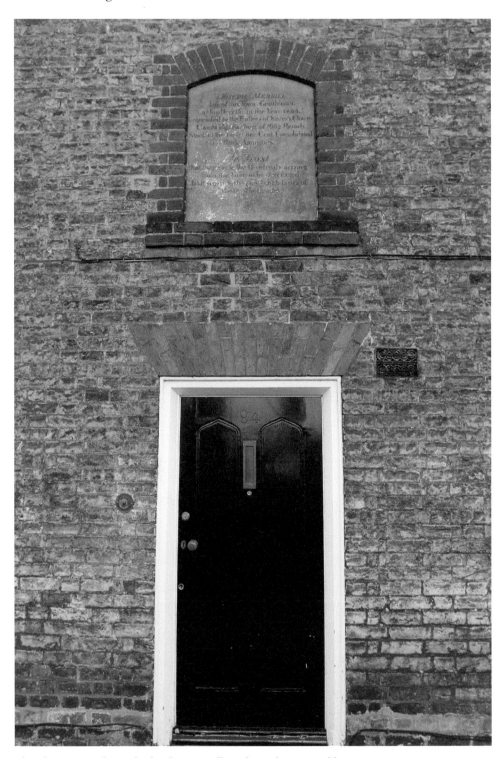

The plaque on Jackenett's almshouses tell us about the original bequest.

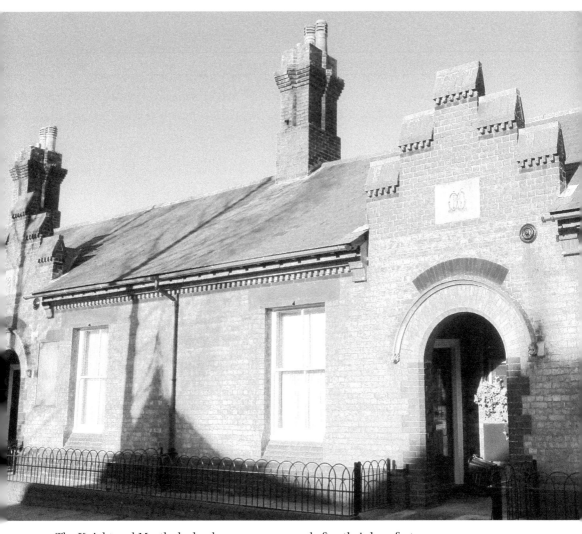

The Knight and Mortlock almshouses were named after their benefactors.

by the Cambridge United Charities who offer places in their various residential properties to people over fifty-five years of age with limited financial resources who have lived in Cambridge for at least two years.

Apples

Arguably, one of Cambridge University's most famous alumni is the mathematician, physicist and astronomer Sir Isaac Newton. This great man is commemorated in the city in various ways, including by a statue in the chapel of Trinity College where he was an undergraduate and then a Fellow and professor. The statue was created

by the French sculptor Louis-François Roubiliac in 1755 at a cost to the college of £3,000. The Latin inscription on the statue sums up Newton's great contribution to scientific learning, the English translation of which is 'Who surpassed the race of men in understanding'. His best-known written work is the *Principia Mathematica*, which took the world by storm when it was published in 1687 by toppling long-held religious beliefs on how the natural world was ordered.

Newton's apple tree outside the Great Gate of Trinity College.

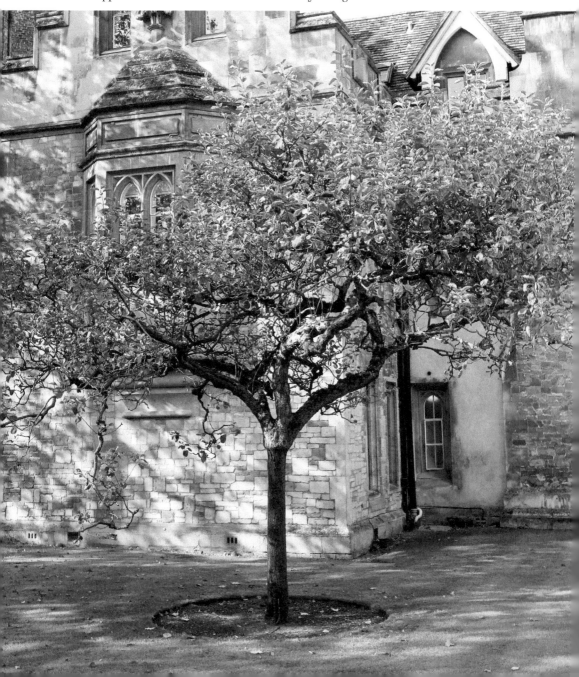

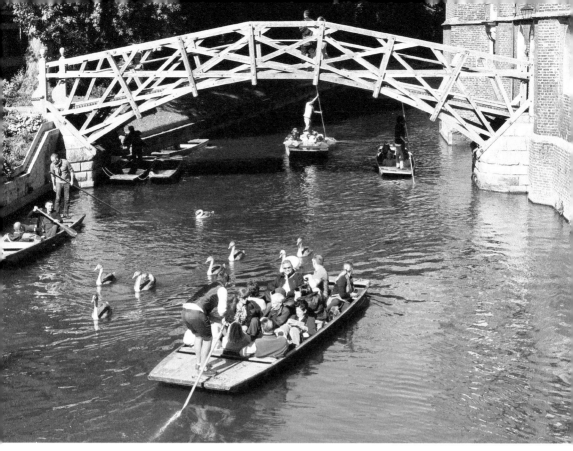

Contrary to popular belief Newton did not design the Mathematical Bridge.

However, it is an apple tree which stands on a small plot of grass outside the Great Gate which draws the most visitors. It is a descendent of the tree in the orchard of Wollsthorpe Manor in Lincolnshire, Newton's family home, where the great man saw an apple fall, thus prompting his theory of gravity. Both are a 'Maid of Kent' variety of eating apple, as is another descendent of the Wollsthorpe Manor tree which stands in the university's Botanic Garden. Of course, Sir Isaac Newton did not actually figure out gravitation by seeing a single apple fall in his garden but these trees serve as a reminder of how science explains the simplest of actions.

One of the most frequently quoted myths about Newton and Cambridge is that the famous physicist designed the so-called Mathematical Bridge which spans the River Cam at Queens' College. In fact, the bridge was first constructed some twenty-two years after Newton's death. College records show that the bridge was designed by William Etheridge, a Suffolk-born master civil engineer and architect, and built by James Essex the Younger. The bridge was completed in September 1750 when college accounts record that the cook was paid 17 shillings and 9 pence for providing a supper for the construction workers. It is also claimed, wrongly, that the bridge was built without any fastenings at the joints, and that when it fell into disrepair and needed to be completely rebuilt in 1905, twentieth-century designers were not able to construct it without using nuts or bolts.

Backs

In 1995, English Heritage designated a swathe of land in the centre of Cambridge as a Grade I Historic Park. The Backs, as this area is called, got its name merely because it is the ground behind several colleges. It stretches from St John's in the north to Queens' in the south with several bridges spanning the River Cam, linking college buildings on the east bank with those on the west side.

In medieval times, the river running through The Backs was a busy, navigable waterway. Then, there were active docks at the back of the colleges and barges carried corn to mills located further south beyond Silver Street bridge, and the land comprised pasture, gardens and orchards. Over time, avenues of trees were planted

Workmen clearing a stream at The Backs.

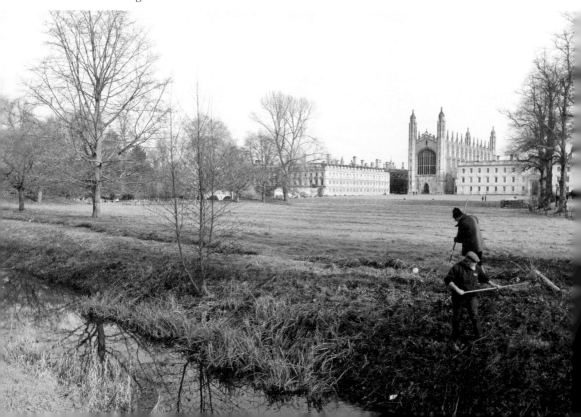

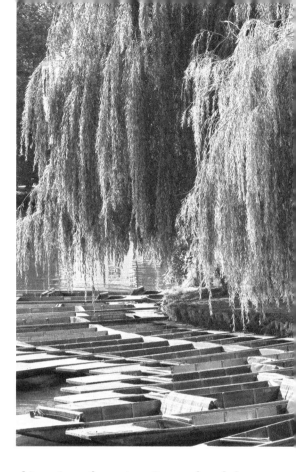

Punts lined up waiting to be hired.

and, since the Cam had ceased to be a working river, the university employed the famous landscape designer Lancelot 'Capability' Brown to give advice on remodelling the grounds. In the 1770s, Brown laid out the westernmost part now known as the Wilderness, transforming the formal seventeenth-century layout into a more natural landscape. He also presented an ambitious plan for reshaping the entire area which included creating a grand serpentine lake and planting clumps of trees. Since the project would have involved huge expense, as well as the removal of three bridges, Capability Brown's plan was never implemented.

In 1879, Henry James described The Backs in his *English Vignettes*: 'Six or eight colleges stand in a row, turning their backs to the river; and hereupon ensues the loveliest confusion of Gothic windows and ancient trees, of grassy banks and mossy balustrades, of sun-chequered avenues and groves, of lawns and gardens and terraces, of single-arched bridges spanning the little stream.'

Today, this stretch of the river is populated by students, tourists and cows, and the most popular activity here by far is punting (at least for the humans!). In *Three Men in a Boat* Jerome K. Jerome says, 'Punting is not as easy as it looks', and many a Cambridge student and tourist alike has learned this to their cost when they end up fully clothed in the river. Pleasure punting was introduced in the city in the early 1900s and today it is the most popular and enjoyable way to appreciate the splendour of Cambridge's architecture, as well as the tranquillity and beauty of The Backs.

Beer

It is probably no coincidence that the dramatic increase in the number of breweries in Cambridge happened after the coming of the railway in 1845. By 1880, the town boasted over forty brewers who were helped greatly by the plentiful supply of local barley and good-quality water. Many of these establishments – which often had an adjacent pub offering their beer – sprung up in the areas either side of the railway line. As train traffic had increased, so had the size of Cambridge, with many new settlements being created such as New Town, Sturton Town and Romsey Town, to house a large number of incomers, the majority of whom were employed by the railway.

Following the Parliamentary Enclosure Acts of the early nineteenth century, the open fields which were once where Romsey Town now lies, had been divided into small strips of land. It was these pieces of land that were sold off for housing and so the rows of residential properties built in the 1880s and '90s often follow the old field boundaries. This was a time of the dominance of Britain over its empire, which stretched across the world, and many of the new streets were named after Queen Victoria's colonies such as Malta and Cyprus. We also find Madras, Hobart, Natal and Montreal Roads after parts of the British Empire, for India, Australia, South Africa and Canada, respectively. The Empress pub in Thoday Street is another clear example of the patriotic naming of new-builds at that time.

The patriotic Empress pub in Thoday Street.

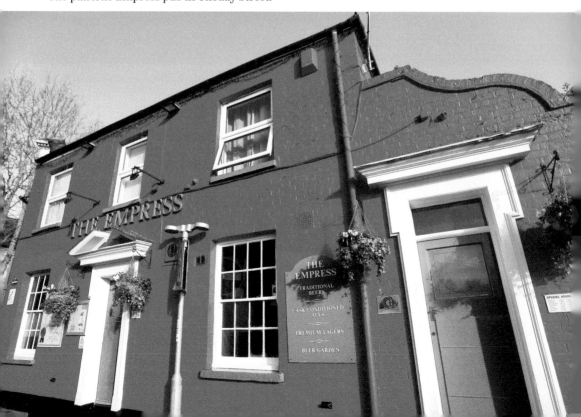

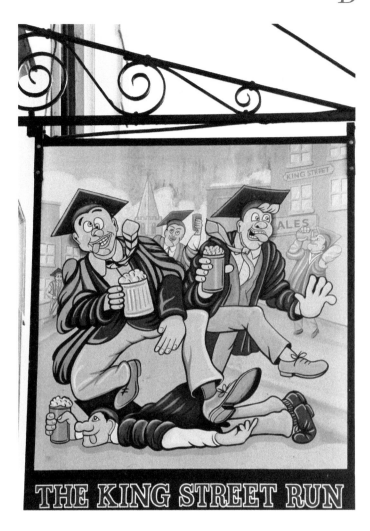

The pub named after a university drinking tradition.

Of course, drinking was not confined to the working classes and there were also several breweries and many public houses in the centre of Cambridge long before the railway arrived. The early nineteenth-century publication *Gradus ad Cantabrigian* (subtitled *New University Guide to the Academical Customs*) records, 'We have ourselves quaffed no small quantity of this inspiring beverage'. The traditional custom of student drinking reached a new level in the 1950s when a trio of undergraduates from St John's College and a group of medical students instituted the King Street Run. Following a debate over whether the male bladder could hold more than four pints, the two groups agreed to settle the argument by having a drink in every pub in King Street without urinating. Thus, the King Street Pint to Pint Club was constituted whereby if any members were able to drink eight pints without emptying their bladder or being sick, they were awarded a special navy-blue tie decorated with the image of a tankard surmounted by a crown. It became a highly sought-after prize!

Books

Cambridge is a city crammed full of books from ancient to modern. The purpose-built, sixteenth-century Old Library of Trinity Hall is the oldest library in Cambridge still in its original setting. Other college libraries constructed after this one followed its sensible design of housing the books on the first floor, safe from damp and flooding of the Cam. In an age before the electric light bulb, many were also aligned from east to west to allow for as much sunlight to flood in. The Old Library is one of the few surviving chained libraries in the country: the founder of the college and of the original library, William Bateman, Bishop of Norwich, stipulated that 'All books of the College to be kept in some safe room' and that they were to be 'fastened with iron chains'.

The Pepys Library at Magdalene College comprises 3,000 volumes from the famous diarist's own collection. It includes his six-volume journal covering the years 1660 to 1669. Samuel Pepys had studied at Magdalene where college records show that he was not the model student. On 21 October 1653, the young Pepys was officially reprimanded for having been 'scandalously overseen in drink the night before' and in his own diary, Samuel Pepys looks back to his Cambridge days of drinking his 'bellyful' of college beer.

The current University Library is altogether very different architecturally, but no less important. It is one of just six libraries in the United Kingdom entitled to claim,

The *Bibliotheca Pepysian* which bears Samuel Pepys' arms and motto.

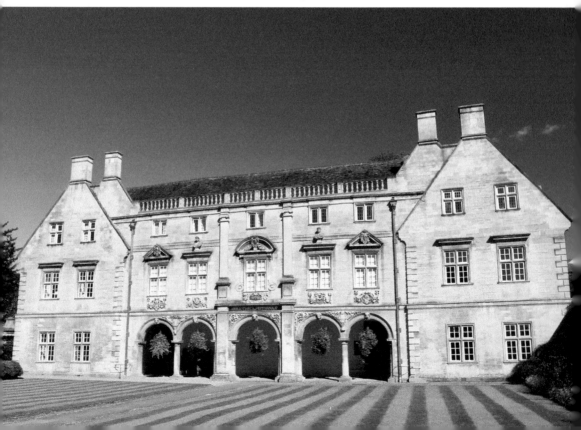

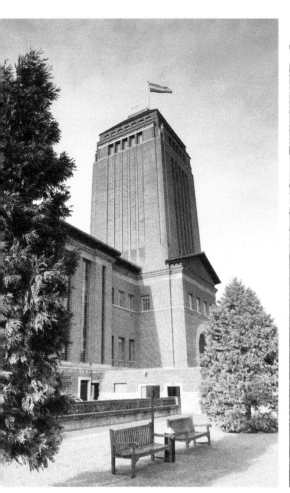
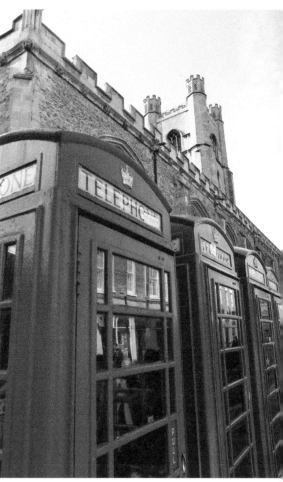

Above left: One of the country's six legal deposit libraries.

Above right: Gilbert Scott's phone boxes – a design echoed in the university library tower?

free of charge, a copy of all books, journals, printed maps and music published in the country. The building, completed in the 1930s, was designed by Sir Giles Gilbert Scott and resembles some of the industrial buildings he conceived, such as Battersea Power Station in London. Because of this, many derogatory comments have been made about the library building over the decades. However, at the opening ceremony, George V managed to find some suitably diplomatic words to describe it, referring to the tower as 'a fine erection'. It has been suggested that the design of this tower was influenced by another of Gilbert Scott's creations: the classic red K2 phone box which first appeared in 1924.

Clink

From its earliest beginnings through to the admission of its first women students in the 1870s, Cambridge University worked hard to segregate their male students from the fairer sex that inhabited the town. Although the colleges employed female servants, called bedders, they tended to take on only those women deemed too old or unattractive to lead the young men astray. In 1635, it was decreed that only women over fifty years old should be given such jobs. However, it was clearly difficult to keep students away from young women. When Daniel Defoe visited Cambridge in the 1720s, he observed 'In some cases the Vice-Chancellor may concern himself in the town, as in searching houses for the scholars at improper hours, removing scandalous women, and the like.' The university authorities had the power to arrest and lock up local women suspected of being prostitutes. They were incarcerated in a cramped and unhealthy house of correction called the Spinning House, so named because until the early nineteenth century the inmates worked at spinning yarn.

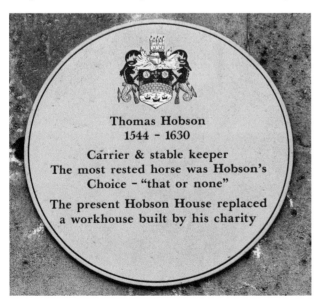

The Spinning House was founded by Thomas Hobson.

County Hall replaced the County Gaol.

The Borough of Cambridge had first been granted the right to its own gaol in 1224, which had been situated in various places in the town including next to the Guildhall and, until 1878, on the south-east side of Parker's Piece. It was then demolished, and the prisoners transferred to the County Gaol, which had been on the site of the old Norman castle since at least the mid-fourteenth century. In the early 1800s, a new prison building had been constructed in place of the old one, which had reached capacity. This new building was based on the idea of a panopticon which was the invention of Jeremy Bentham, the philosopher and social theorist. He designed an institution where all the inmates could, in theory, be observed by a single watchman without the prisoners being able to tell whether or not they were being watched. This was achieved by constructing a central round or octagonal surveillance block, where the Governor was housed. The inmates were housed in four blocks radiating at right angles from the central building.

The prison regime was harsh and included the use of a treadmill, the invention of the engineer Sir William Cubitt. It was a huge revolving cylinder made from iron and wood, with steps like the slats of a paddle wheel. Prisoners took it in turns to step from one slat to the other in order to turn the wheel. It was described by critics as 'the most tiresome, distressing, exemplary punishment that has ever been contrived by human ingenuity'.

Cockpit

A rather unpleasant sport enjoyed by our ancestors was cockfighting or cocking. It was popular among both the upper and lower classes in society. Indeed, a succession of English kings such as James I, William III and Charles II loved the sport. The game even became a national sport and exclusive schools were set up to teach students the business of cockfighting, such as breeding and keeping the gamecocks in tip-top condition.

Cockfights traditionally took place in inns and taverns, or else in specially adapted cockpits which included a wooden platform on which the fight between the two birds took place. In Cambridge, the most important regular contest was held on Market Hill on Shrove Tuesday to which townspeople, as well as students, came. Although the university statutes prohibited cockfighting within 5 miles of Cambridge, this regulation was often ignored. In 1759, two Cambridge constables were found guilty of failing to report to the Guildhall on Shrove Tuesday. Their job should have been to arrest all those taking part in the cockfights.

Publicans were among the first commercial sponsors of cocking, and the inns would make handsome profits from selling food and drink to the spectators until the sport was banned. The cocks were kept in bags while bids were raised for and against the opponents, until such point as the birds were produced ready for the battle, each wearing silver spurs. The ensuing fights were bloodthirsty and violent. One report from the eighteenth century describes the feathers and blood that flew about, while all around were 'great shouts of triumph and monstrous wagers' among the spectators.

The Mitre pub in Bridge Street stands on the site of two former inns, one of which was called the Cock & Magpie. It is possible that its name was derived from one of the blood sports carried on here. The Green Dragon Inn in Chesterton is arguably the oldest surviving coach house in Cambridge and during the nineteenth century the pub had a cockpit. It is also said that Oliver Cromwell, who frequented the Green Dragon

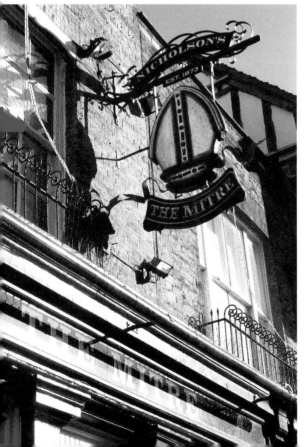

The successor to a pub which may well have hosted cockfights.

The Green Dragon Inn had a cockpit.

during his student days in Cambridge in the early 1600s, practised knife-throwing skills by aiming to lodge his blade into the lintel of the fireplace. As Lord Protector, Cromwell attempted, unsuccessfully, to ban cockfighting. It took until 1849 for the sport of cocking to be criminalised.

Cold War

Some may think that the connection between spying and Cambridge University is merely decades old. On the contrary: one of Elizabeth I's many spies was Christ's College graduate Christopher Marlowe, and Dr Dee, a founding Fellow of Trinity College and astrologer to the Virgin Queen, is said to have been the first man to use the insignia 007, at the foot of his letters to the monarch. It was also Trinity College which harboured four of the Cambridge Five: Guy Burgess, Donald Maclean, Kim Philby, Anthony Blunt and John Cairncross. Whilst undergraduates at the university in the 1930s, these individuals were recruited as spies by the Russian intelligence services. Burgess and Maclean went on to work at the British Foreign Office where

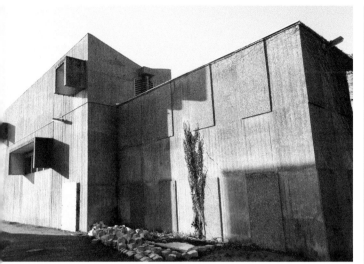

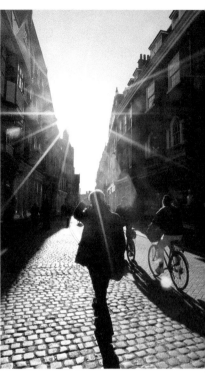

Above: An eerie reminder of the Cold War.

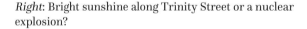

Right: Bright sunshine along Trinity Street or a nuclear explosion?

they leaked secrets to Russia before having to flee to Moscow in 1951. Kim Philby followed them there a decade or so later after having spied successfully for Russia from within the British Secret Service. Anthony Blunt, who became an art historian, was said to have acted as talent spotter in Cambridge for the Russians, but later in life, after he had been unmasked, commented 'The atmosphere in Cambridge was so intense, the enthusiasm for any anti-fascist activity was so great, that I made the biggest mistake of my life.'

In a now residential corner of Cambridge, there is a chilling reminder of the threat to British security during the Cold War. Built in the 1950s, it was originally planned that it would be one of a small network of regional war rooms designed to house 300 key civil and military personnel in the event of nuclear war. It is a two-storey structure, with a basement, constructed from 1.5-metre-thick concrete walls with a single, combination-locked metal door, designed to withstand a nuclear bomb blast. Inside it has rooms allocated to each ministry of state, as well as everything necessary for the people to live and sleep. In the centre of the basement is a war room, flanked on two sides by observation rooms connected by reinforced convex screens. A large diesel generator, wiring and soundproof walls were also part of its original features. The building was, of course, never needed and in the 1990s the University of Cambridge bought the site. There are plans for the bunker to be converted into long-term, temperature-controlled storage.

D

Discovery

When Francis Crick and James Watson walked into the Eagle pub in Bene't Street one February morning in 1953 and declared 'We have found the secret of life!', it was the culmination of decades of study by this pair of scientists. It was their significant discovery of the double helix structure of DNA, and therefore the unlocking of the genetic code of every human being, that earned Crick and Watson a place in the history books, as well as the Nobel Prize for Medicine in 1962. However, it was the earlier, brilliant work of a largely unknown and unforgotten Cambridge graduate, Rosalind Franklin, which allowed Crick and Watson to crack the DNA code.

Franklin had studied chemistry at Newnham College during the Second World War and was later awarded a research fellowship at Cambridge. It was here that she worked to determine the arrangement of atoms in solids which was to help Crick and Watson's discovery of the DNA double helix model. Rosalind Franklin died before the two men received their Nobel Prize and many believe that she, too, would have shared this award. She once wrote 'My main aim is to do my best to improve the lot of mankind, present and future,' and her legacy lives on in an ambitious undertaking, the Human Genome Project, which aims to catalogue all the genes in the human body. The Wellcome Sanger Institute, situated just outside Cambridge, is part of this worldwide, collaborative project.

Such monumental discoveries may not have taken place in Cambridge without the enthusiasm of the university's chancellor in the mid-nineteenth century, Prince Albert, the husband of Queen Victoria. Albert was an advocate of discovery and innovation, and he encouraged the development of science at the university. His successor as chancellor, William Cavendish, the 7th Duke of Devonshire, provided £6,300 for the construction of a physics laboratory, now known as the Cavendish Laboratory, which opened in 1874. Although now on a different site, it continues to facilitate research by the brightest scientists in the world. To date, twenty-nine members of the Cavendish Laboratory are Nobel Laureates, in chemistry and medicine, as well as physics. The names of Francis Crick and James Watson are joined by Sir Joseph John Thomson, who discovered the electron and the first subatomic particle, and Lord Ernest Rutherford who is known as the father of nuclear physics.

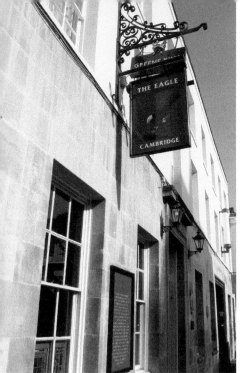

Above left: The Eagle, where many a scientist has quenched their thirst.

Above right: The Old Cavendish Laboratory in Free School Lane.

Left: Francis Crick's former residence displays a golden helix.

Drama

The University of Cambridge cannot just lay claim to many scientific breakthroughs. Over the centuries, it has also boasted a plethora of alumni who have become famous actors, actresses and playwrights. In Tudor times, University of Cambridge students performed all manner of plays, sometimes written by themselves. Acting was encouraged by the university authorities and at Queens' College, performing or attending plays was even made compulsory. The playwright Thomas Heywood, who was at Cambridge in the 1590s, commented that he saw 'tragedies, comedies, histories, pastorals and shows, publicly acted by graduates of good place and reputation'. William Shakespeare's contemporary Christopher Marlowe is probably the most famous Elizabethan playwright to have been educated in Cambridge. One of the well-known drama clubs in Cambridge today is the Marlowe Society. It was founded in 1907 by a group of students who wanted to revive the presentation of plays by the great Elizabethan playwrights. It produces a remarkable number of graduates who have gone into the theatre industry including Sir Ian McKellen, Derek Jacobi, Emma Thompson and Sam Mendes.

The Cambridge Arts Theatre hosts plays staged by the Marlowe Society.

The oldest of the university's surviving dramatic societies is the ADC or Amateur Dramatic Club, and is, in fact, the oldest in the country. Plays have been performed on the site of the current ADC Theatre in Park Road since 1855. The first members had to meet in secret as they faced stern opposition from the university authorities. Even when the then Prince of Wales, the future Edward VII, joined the ADC, productions were strictly controlled until rules were gradually relaxed.

The ADC Theatre is now also home to probably the most famous comedy drama club in the world, the Footlights. The group's first formal performance took place in June 1883, although it had played to local audiences in the Cambridge area for some time before this. It included one performance with a cricket match at the pauper lunatic asylum. Many household names of British drama and comedy have cut their acting teeth in Footlights productions, including Olivia Colman, David Mitchell, Sue Perkins, Mel Giedroyc, Stephen Fry and Hugh Laurie, three of the *Monty Python's Flying Circus* crew (John Cleese, Eric Idle and Eric Chapman) and all three of *The Goodies* (Bill Oddie, Tim Brook-Taylor and Graeme Garden).

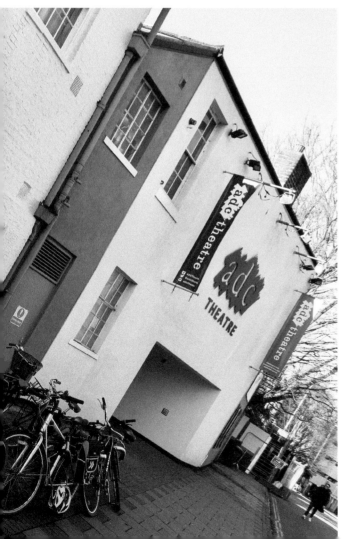

Home to the famous Footlights.

E

Evolution

In 2009, Christ's College celebrated the bicentenary of the birth of arguably its most illustrious alumnus. A series of events took place throughout the year and, among other related projects, a bronze sculpture of the man was commissioned. It depicts Charles Darwin as a twenty-two-year-old student and was created by another Cambridge graduate, Anthony Smith. The statue now stands in the Darwin Garden, created in one of the courts in the college. The garden contains a wide range of plants that the naturalist discovered and studied. They include ivies and hollies, which are native to

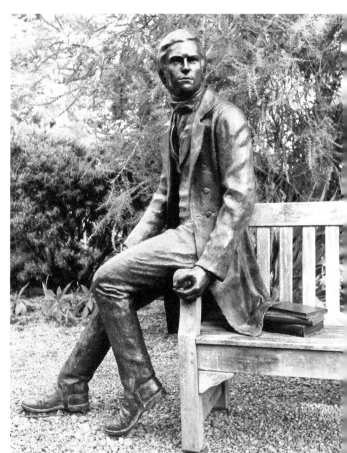

Charles Darwin's statue at Christ's College surrounded by plants he discovered.

Senate House was the scene of a monkey prank in 1877.

the Canary Islands, and many South American plants such as the monkey-puzzle tree and *Berberis darwinnii*, an evergreen shrub discovered by Darwin in 1835. Other trees, bushes and plants from Australia, the Galapagos Islands, Polynesia and South Africa feature too.

Charles Darwin originally studied medicine at Edinburgh University but soon decided he wanted to train to be a clergyman and moved to Christ's College in 1827 where he studied divinity. Here, too, his heart was not in his studies and Darwin spent more time collecting beetles in the local fens. He attended lectures and discussion groups led by a professor in botany, Revd John Stevens Henslow, who was to become a close friend and mentor. Henslow encouraged the young Charles' interest in plants. Another influence on Darwin was the geologist Adam Sedgwick. It was Henslow who secured the newly graduated Charles Darwin a place on the HMS *Beagle* on its planned voyage to survey the coast of South America. Later in his career Darwin commented, 'The voyage of the Beagle has been by far the most important event in my life, and has determined my whole career.'

As a result of his studies, Darwin published his first book *On the Origin of Species* in 1859, followed by *The Descent of Man* in 1871. Both books contained controversial theories about the evolution of animals and the origin of the human race, which he believed was evolved from the apes. Satirical cartoons appeared in the newspapers mocking his claims, depicting Darwin with a monkey's head. In 1877, when Charles Darwin returned to Cambridge to receive an honorary doctorate, a prankster dangled a stuffed monkey dressed in academic robes from the gallery of the Senate House, which 'excited some mirth'.

F

Fire

During the sixteenth century, England saw many Tudor monarchs on the throne, each one with their own view on religion. It was this seemingly constant about-turn in the religion of the country which could literally mean life or death for clerics. Legislation was altered in accordance with the particular faith of the king or queen at that time and those not following the right religion were deemed to have committed treason, punishable by death. Many Protestant martyrs were executed during the reigns of Henry VIII and Mary I, and Catholics under Edward VI and Elizabeth I. Among those Protestants who were put to death were the respected churchmen Archbishop Cranmer, Bishop Latimer and Bishop Ridley, all of whom had been fellows at the University of Cambridge although executed in Oxford.

Cambridge was, fortunately, the site of just one execution of a Protestant. John Hullier was an English clergyman who had been educated at King's College before becoming vicar of the Cambridgeshire village of Babraham. In 1556, under Mary I's Catholic reign, Hullier was condemned to die for refusing to renounce the Protestant faith. Although traitors were normally hanged, drawn and quartered, those judged guilty of heresy were burned at the stake. John Hullier was taken to Jesus Green on Maundy Thursday, 16 April 1556, and suffered this death by burning.

Some 425 years later, the Great Court at Trinity College featured in the central scene in the film *Chariots of Fire*. Although this part of the blockbuster movie was not actually filmed at Trinity, the scene shows the Jewish athlete Harold Abrahams in 1919 becoming the first person ever to complete the Trinity Court Run. This tradition involves attempting to run around the courtyard – a course of approximately 370 metres – within the length of time that it takes the college clock to strike the hour of twelve (actually twenty-four chimes in total because the clock strikes the hour twice, first on a low note and then on a much higher one). Depending on the winding of the clock, this takes between 43 to 44½ seconds. The race is run annually on the day of the Matriculation Dinner. In October 1988, the middle-distance runners Sebastian Coe and Steve Cram ran the famous race, both failing to beat the clock.

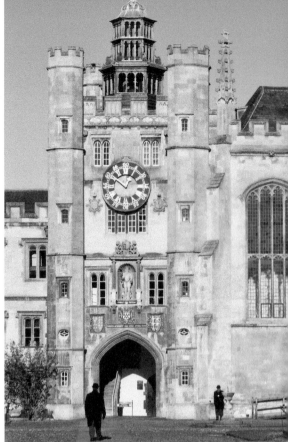

Above left: A chilling execution once took place on Jesus Green.

Above right: Few athletes have ever been able to beat the Trinity College clock.

Flora

On 27 April 2011, Elizabeth II formally opened the world-class Sainsbury Laboratory at the Botanic Garden in Cambridge. It houses over 120 scientists and support staff, all members of the university, as well as an herbarium: a collection of over a million dried and pressed plant specimens from all over the world. The academics' aim is to study how plants grow and develop, thus contributing to our understanding of how to ensure a sustainable supply of food and other plant products.

This laboratory is one of the latest developments in the 40-acre Botanic Gardens which lie a mile to the south of the city centre. Before the current site was acquired, an earlier Physik garden had been established by the university on 5 acres of land off Downing Street. There 4,000 varieties of plants were grown that were used primarily for the botanical education of medical students, rather than to be studied by naturalists. This garden, first laid out in 1762, started to run into problems, not least because the jackdaws who nested in nearby chimneys stole the plant labels to build

Above: The Sainsbury Laboratory is the latest addition to the Botanic Gardens.

Right: Another of Newton's apple trees.

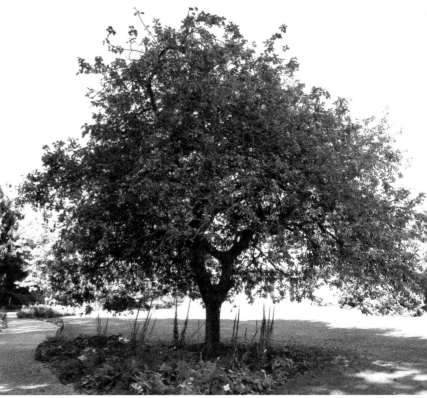

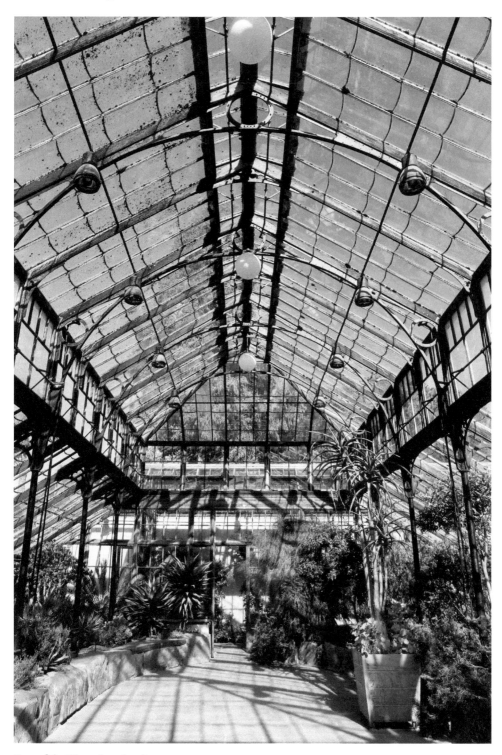

One of the Victorian glasshouses.

their nests! Luckily, a recently appointed professor of botany, with the necessary energy and vision, gave the garden a new lease of life and a new location.

John Stevens Henslow was just twenty-nine years old when he accepted the Chair of Botany in 1825. He reinvigorated the study of plant science at the university. Henslow persuaded the authorities to use a large cornfield for a new Botanic Garden, although at first, he was only able to use the western half of the site. He enlisted the help of Andrew Murray, the first Garden Curator, who designed a landscape which represented the Gardenesque style of the early Victorian era. It included a lake, herbaceous beds, conifers and other trees. The garden therefore became a place for botanical study rather than its previous medical use. Several glasshouses were added along the northern boundary in the late 1840s and early 1850s which enabled Henslow to keep those plants native to warmer climates. Thanks to a generous legacy by Reginald Cory in 1934, the eastern half of the original 1831 land was gradually developed too. Today's visitors walk in the footsteps of those who were first allowed access in the 1840s; from the very beginning, members of the pubic were encouraged to visit if they were 'respectably dressed'!

Founders

Despite the age-old rivalry between the universities of Oxford and Cambridge, the university in Cambridge may owe its existence to Oxford scholars arriving here in 1209 following a major dispute between the university and townspeople of Oxford. At first, these scholars lived in hostels, which later became colleges when wealthy benefactors endowed them with money and land. The earliest college in Cambridge is Peterhouse, which was founded in 1284 by the Bishop of Ely to provide a permanent place for students to live, study and pray. At that time, most early scholars were priests. Eight more colleges followed in quick succession over the next seventy years, founded mostly by non-clerical patrons.

Trinity College was founded by Henry VIII in 1546 and is, not surprisingly, one of the best endowed of colleges. The money came predominantly from the wealth of the numerous monasteries across the country the monarch had dissolved. It combined two earlier colleges: Michaelhouse, founded in 1324, and King's Hall, which had been established by Edward II in 1317. Trinity grew rapidly in importance and by 1564 it accounted for around a quarter of the total members of the university. Many colleges boast magnificent statues of their founders on their gatehouses, and Trinity is no exception. The statue of Henry VIII on the Great Gate dates from around 1615, and originally showed the king resplendent with his golden orb and sceptre. However, tourists who study the statue carefully enough will notice that the sceptre is nothing but a simple wooden chair leg. Until recently, it was thought that the original object was swapped for the chair leg as a student prank in the nineteenth century. However, a window cleaner has since come forward to own up that he put it there in the late twentieth century. He claims that he noticed the sceptre was missing when cleaning

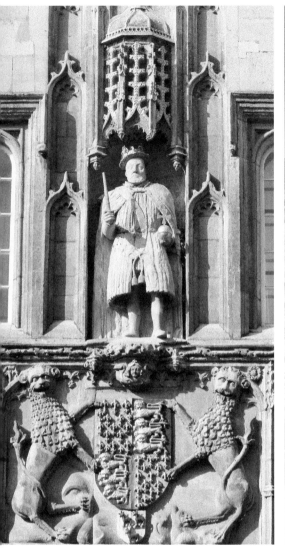

Above left: Henry VIII, resplendent with orb and table leg!

Above right: Gonville and Caius College's two founders together with Bishop Bateman.

the windows of the gatehouse, and thinking that students must have removed it, quickly replaced it with the first thing to hand. It has been there ever since!

Gonville and Caius College is the fourth oldest college in Cambridge, having been established as Gonville Hall by cleric Edmund Gonville in 1348, and then refounded in 1557 by former student and Fellow John Caius. Up to the sixteenth century the study of medicine had been purely theoretical, but in the year he endowed the college, Dr Caius conducted the first recorded demonstration in Cambridge of the dissection of a human body.

G

Games

The baiting of bears and bulls for pure enjoyment was a popular pastime in the sixteenth and seventeenth centuries. However, the university complained that the organisers of such entertainments in the town distracted the students from their studies. This led to an edict from James I in 1604 which authorised the university to prohibit 'all and all manner of unprofitable or idle games, plays, or exercises especially bull-baiting, bear-baiting ... games at loggets, nine-holes, and all other sports and games whereby throngs, concourse, or multitudes are drawn together, or thereby the younger sort are or may be drawn or provoked to vain expense, loss of time, or corruption of manners'. The ban was to be enforced within a radius of 5 miles of Cambridge.

Despite this opposition from the university, the townspeople forged ahead and erected a bullring on Peas Hill at a total cost of 14 shillings and 6 pence. Bear-baiting continued in Cambridge at least into the eighteenth century, as the *Cambridge Chronicle* of 30 November 1749 reports: 'This is to acquaint the Publick that on Monday next in the Afternoon, the Great Muscovy Bear will be baited at the Wrestler-Inn in the Petty Cury, Cambridge.'

Peas Hill was once the site of a bullring.

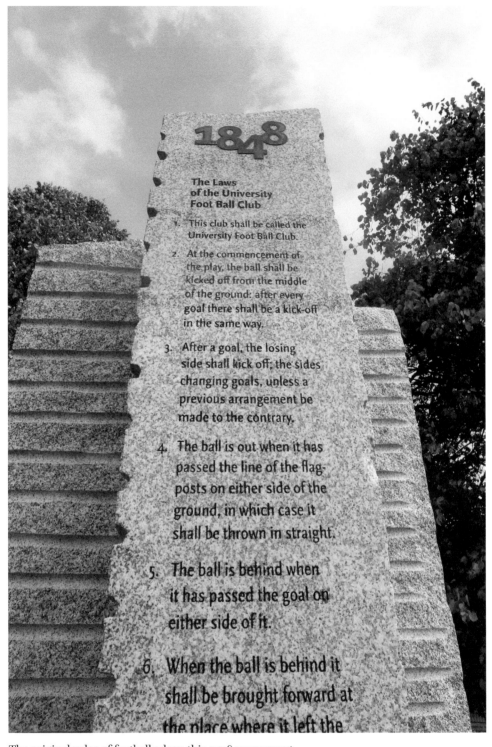

1848

**The Laws
of the University
Foot Ball Club**

1. This club shall be called the
 University Foot Ball Club.

2. At the commencement of
 the play, the ball shall be
 kicked off from the middle
 of the ground: after every
 goal there shall be a kick-off
 in the same way.

3. After a goal, the losing
 side shall kick off; the sides
 changing goals, unless a
 previous arrangement be
 made to the contrary.

4. The ball is out when it has
 passed the line of the flag-
 posts on either side of the
 ground, in which case it
 shall be thrown in straight.

5. The ball is behind when
 it has passed the goal on
 either side of it.

6. When the ball is behind it
 shall be brought forward at
 the place where it left the

The original rules of football adorn this 2018 monument.

Town and gown also came to blows – quite literally – during rival football matches. In 1857, in a match between students and Chesterton village, 'many university representatives had their head broken in by staves and others had to take refuge in the river'. Earlier reports of violent behaviour on the pitch had convinced those involved that a set of rules for the game should be agreed upon. So, in 1848, the Cambridge University Football Club wrote a set of eleven rules for their matches, nailing copies to trees surrounding Parker's Piece in the city. These laws included a simple version of the offside rules which forbade 'loitering' near the opponent's goal. They also laid the foundation for the now complex decision on fouls. Although it was later widened, the width of the goal was set at 15 feet, a gap determined by the space between the large lime trees that lined Parker's Piece along the north-east edge. In 1863, the Football Association of England adopted most of these rules and added more. To mark this creation of the modern game of football, a monument entitled *Cambridge Rules 1848* was unveiled on Parker's Piece in May 2018 which has inscribed on it the original rules in seven languages, reflecting the now universal appeal of football.

Gilds

In medieval times, Cambridge was dominated by the church, and one institution which played a central role in the social, as well as religious, life of the townspeople was the gild. These gilds were separate institutions to the craft and trades guilds, and in Cambridge there were over thirty such religious gilds. By being a member of a gild, a man or woman could claim financial help should they be unable to work and therefore struggle to feed themselves and their family. When they died, they also earned the right to be prayed for by priests, employed by the gild. The gilds expended a great deal of money on candles to light their churches and members often taxed their tenants to give to the gild to buy candles. Many people resented having to play this so-called candle rent.

The Gild of St Mary in Cambridge is first mentioned in surviving records in the late 1200s. Many of the leading townsmen were members and women were also eligible to join. The Gild of the Holy Trinity was a wealthy gild, demanding an entrance fee of 13 shillings 4 pence plus an annual subscription of 2 shillings in the late fourteenth century. One of the least well-endowed of such institutions in Cambridge was the Gild of the Assumption, which required an annual subscription of just 10 pence. However, members were expected to be upstanding citizens and the gild warned that any of their number who haunted the streets by night, or played chess or dice, might be expelled if they did not mend their ways!

These medieval gilds were all dedicated to a particular saint, and members would celebrate their saint's day as well as holding feasts and plays throughout the year. Records of the Gild of Corpus Christi, which met in St Bene't's Church, tell us that in 1353 they performed a play called *The Children of Israel*. Each year, the members

St Bene't's
Church
was home
to the Gild
of Corpus
Christi.

would hold a spectacular procession through the town, holding a representation of
the Body of Christ in a magnificent silver-gilt tabernacle. The Gild of St Katherine also
held their meetings in St Bene't's Church. This gild was founded by ten Cambridge
skinners – those who skinned animals and traded in their hide and fur – although
membership was not confined to this profession. Like other gilds, they had a common
badge or livery to distinguish their members from others.

H

Hobson's Choice

A visitor to Cambridge is likely to come across the name of one former resident more than almost any other. Far from being a household name, nevertheless he contributed much to medieval Cambridge as well as giving us an expression in common usage in the English language today.

Sanitation in the town in the Middle Ages left much to be desired. One of the main drinking water supplies was the King's Ditch which had been first dug as a defence

Below left: Hobson's conduit in Trumpington Street.

Below right: The hexagonal fountain was relocated from the marketplace to Trumpington Street.

for Cambridge in the tenth century. In 1388, when an anti-pollution law was passed, the ditch and other sources of water were described as full of 'dung and filth of garbage and entrails, as well of beasts as of other corruptions' that were infecting the air so that 'intolerable diseases daily happen'. So, in 1610, Thomas Hobson and a group of prominent local businessmen financed the construction of a conduit to carry natural spring water through the town in open, artificial rivers running along the roads. One branch of the conduit flowed into the marketplace, where a hexagonal fountain was built. The businessman also established the Hobson Conduit Trust to ensure its upkeep.

Thomas Hobson was a courier and carrier by profession. He organised the carrying of letters on horseback between Cambridge and London, also hiring out the forty horses he owned and kept in his stables in Trumpington Street for those who needed to ride out of the town. Much of his rental business came from university academics and students, which ensured a thriving trade. Naturally, everyone wanted the best and strongest horses, especially if they were to ride a long distance, and so Hobson devised a system whereby all his horses were ridden equally, offering fairness for his customers. In 1712, *The Spectator* published an article in memory of Hobson describing his policy: 'When a man came for a horse he was led into the stable, where there was great choice, but he obliged him to take the horse which stood next to the stable-door; so that every customer was alike well served according to his chance, and every horse ridden with the same justice: from whence it became a proverb, when what ought to be your election was forced upon you, to say Hobson's choice.' This expression, however, dated from much earlier: the poet John Milton had immortalised the expression in two commemorative epitaphs to the enterprising Thomas Hobson.

I

Ice

'For God's sake look after our people' were the last reported words spoken by Captain Robert Falcon Scott who died returning from the South Pole in 1912. The University of Cambridge certainly took these words to heart, as well as his emphasis on the importance of science. So much so that academics founded the Scott Polar Research Institute in 1920 in memory of Captain Scott and his companions. It is the oldest such centre within a university anywhere in the world. From these beginnings, in a single room, grew not only this research centre but several other centres concerned with polar issues, all based in the city, including the Cambridge Arctic Shelf Programme and the International Whaling Commission.

The Scott
Polar Research
Institute
Museum.

The Scott Polar Research Institute Museum at their centre in Lensfield Road delights old and young alike and is one of the real gems amongst the many museums in the city. It houses many exhibits from Scott's two expeditions to the Antarctic, including Edward Wilson's paintings and drawings. You can also see the chronometer from Ernest Shackleton's doomed ship *Endurance* from the explorer's 1907 attempt to reach the South Pole. The museum's Arctic gallery holds some fascinating items from nineteenth-century explorations of the region. One of the most remarkable of these is a functioning barrel organ which Sir William Parry took on four separate expeditions between 1819 and 1827. The organ plays forty tunes, including the National Anthem.

Another Cambridge-based institution is the British Antarctic Survey which has been the body responsible for coordinating and undertaking most of the country's scientific research in the Antarctic for the past sixty years. It originated as a top-secret expedition, code-named Operation Tabarin, which took place during the Second World War. One of the main objectives of this mission was to deny enemy raiding ships safe anchorage on British territories in the South Atlantic. After the conflict,

The British Antarctic Survey located on the edge of Cambridge.

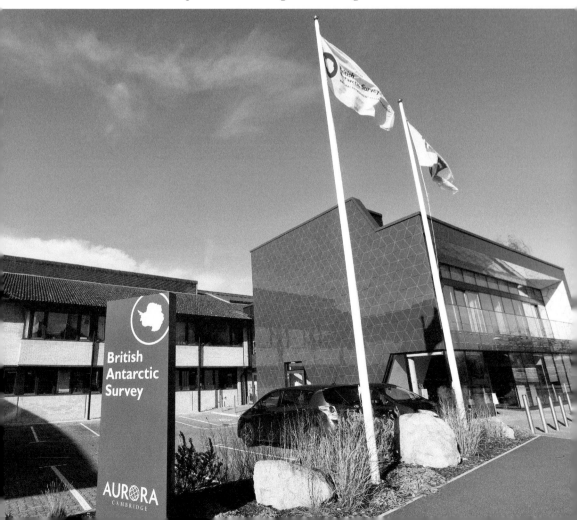

scientific observations and surveys continued under the Colonial Office until it became part of the Natural Environment Research Council in 1967. Today the British Antarctic Survey is a world-leading research centre for earth science and climate change, working with international partners in both the Antarctic and Arctic.

Inspiration

Cambridge has, of course, provided inspiration for writers over the centuries, many of whom studied at the university. The fourteenth-century poet Geoffrey Chaucer was not a scholar there, although the village of Trumpington provided inspiration for *The Reeve's Tale*, the third story in his *The Canterbury Tales*. Chaucer knew the local landowner, Sir Roger de Trumpington, and it is likely that the poet visited since the description of the neighbourhood is so convincing. The two main characters are Oswald, the reeve (the official responsible for the day-to-day management of the lord's estate) and Symkyn, a miller. Chaucer's miller works at Trumpington Mill and used, as its millpond, the now so-called Byron's Pool. Oswald the reeve begins his tale like this:

> At Trumpyngtoun, nat fer fro Cantebrigge,
> Ther gooth a brook, and over that a brigge,
> Upon the whiche brook ther stant a melle;
> And this is verray sooth that I yow telle:
> A millere was ther dwellynge many a day.
> As any pecok he was proud and gay.

In the fictional tale, Symkyn grinds corn for a university college called Soler Hall, which is widely believed to have been based on King's Hall, which was founded in 1317 and later combined with Michaelhouse to create Trinity College.

It is not certain whether the famous Romantic poet swam in the pool now named after him. However, during Lord Byron's undergraduate years in Cambridge – between 1805 and 1808 – he certainly enjoyed swimming, riding, boxing, drinking, gambling and sex; indeed, almost anything other than studying. He was described by one of his contemporaries as 'mad, bad and dangerous to know'. Rather fittingly, given all Byron's extra-curricular activities, he published his first volume of poetry, *Hours of Idleness*, whilst at Cambridge.

When Byron arrived at Trinity College, he was annoyed that the rules prevented him from keeping a dog, so he got a bear instead, arguing that there was no mention that he was not allowed one. The college authorities had no legal basis to complain. Byron said 'I have got a new friend, the finest in the world, a tame bear. When I brought him here they asked me what I meant to do with him, and my reply was "he should sit for a Fellowship."' His pet stayed with Byron until he graduated – Byron, that is, not the bear!

Left: Sundial at Trinity College, successor to Chaucer's fictional Soler Hall.

Below: Lord Byron is said to have swum at this idyllic spot.

Invention

Amidst all the ancient, architectural gems of Cambridge, there is one recent, more curious arrival which attracts the tourists. It is a £1 million clock on public display outside the library of Corpus Christi College which was unveiled by the famous physicist Stephen Hawking in 2008. The clock comprises a giant, rather disturbing grasshopper which sits atop a large gold-plated face, under which a pendulum swings. This face has no hands or digital numbers. Instead, there are three rings of LED lights which, reading from the innermost ring, show the hours, minutes and seconds. The radiating ripples of the clock face allude to the Big Bang – the beginning of time.

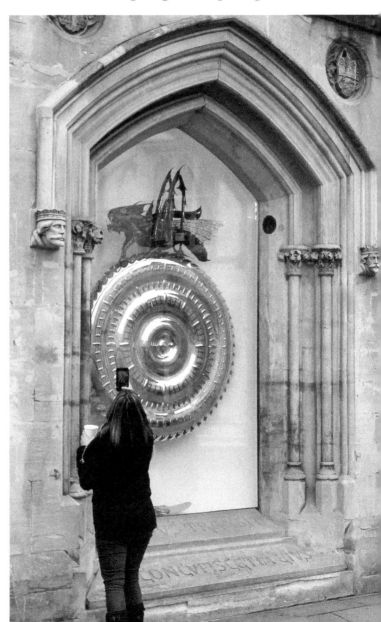

A grasshopper devours time on this giant clock at Corpus Christ.

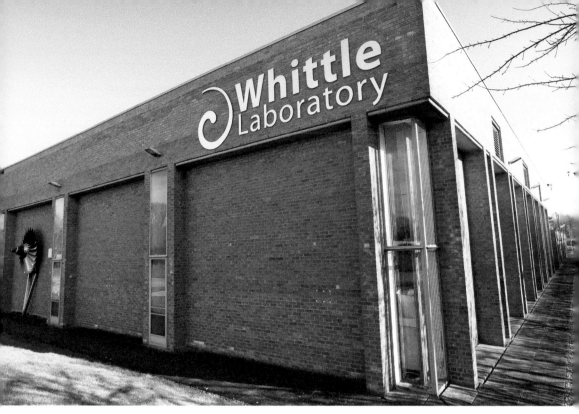

The Whittle Laboratory, named after the inventor of the jet engine.

The Corpus Christi clock was created by Dr John Taylor, an inventor and horologist who is an alumnus of the college. He designed the timepiece as a tribute to the English clockmaker John Harrison who solved the problem of longitude in the eighteenth century. Harrison also invented the grasshopper escapement, a tiny internal device that releases a clock's gears at the swing of the pendulum. One of the two Latin inscriptions on the clock hints at the creation's darker meaning, which in English reads 'the world and its desires pass away'. The grasshopper, a Chronophage meaning time eater, literally devours each minute as it passes with the snap of its jaws. Instead of the usual hourly chimes, there is a rattle of chains and a hammer hitting a wooden coffin.

One twentieth-century invention, developed in Cambridge, is better known throughout the world. Sir Frank Whittle once commented 'My father said inventing the jet engine was easy. Making it work was the difficult bit!' Despite this, the first jet-propelled aircraft was conceived and built in just fifteen months, albeit following several years of study as a mature student in the Engineering Department of the university. Whittle had joined the RAF as an aircraft apprentice, later becoming a pilot. It was during this time that he developed the concept of jet propulsion although the Air Ministry was not interested in taking up the idea. Instead, Whittle established his own company after his Cambridge studies to develop his jet engine. To mark his great achievement, a Department of Engineering laboratory, dedicated to the study of the aerodynamics of turbines, was opened in 1973.

J

Jews

It is believed that Cambridge had one of the earliest provincial Jewish communities. The first Jews had arrived in England after William I's conquest of England, settling first in London and then moving to nearby towns. There is a tradition that the Church of the Holy Sepulchre in Bridge Street, usually known as the Round Church, was once a synagogue. There is no evidence for this, although this idea may be due to the coincidence of the building of this church with the first arrival into Cambridge of people of Jewish faith. The Round Church's design was based on the Holy Sepulchre in Jerusalem and it was built in around 1130. In the twelfth and thirteenth centuries, the Jewish quarter in Cambridge stretched from where the Guildhall stands today, where the community's synagogue was located, right across to the Round Church. In fact, Jews were only allowed to live in this specific area of the town, known as the Jewry.

There is no evidence that Jews ever used the Round Church for their worship.

The city's Jews were victimised in 1266, during a civil war between a number of barons against the forces of Henry III, and in the 1270s they were banished from Cambridge altogether followed by the expulsion of all Jews from England twenty years later. When Jews started returning to the country in the 1650s, some of their scholars began to teach Hebrew at the university. It was not until 1849, however, that Jews, together with Muslims and other non-Christian religions, were able to study for a degree at Cambridge, and it took until 1856 for those of Jewish faith to be awarded a degree.

The medieval Jewry in Cambridge was not exclusively for Jews. The church of All Saints in the Jewry stood in St John's Street from the eleventh century and was rebuilt and enlarged several times over the centuries. However, by the nineteenth century it was still too small for the growing congregation and so it was demolished in 1865 and a new church built in Jesus Lane. The churchyard of the old church is now known as All Saints' Garden and has in its centre a memorial cross.

A memorial cross now stands on the site of the demolished church of All Saints.

Kings

The coat of arms of the city of Cambridge sits proudly over the door of the present-day Guildhall on Market Hill. Not surprisingly, the river, ships, bridge and castle are significant elements in the arms. The shield is supported by two mythical creatures called hippocampi – a cross between a horse and a fish – which were often used in medieval times for places with maritime associations. Although this coat of arms was

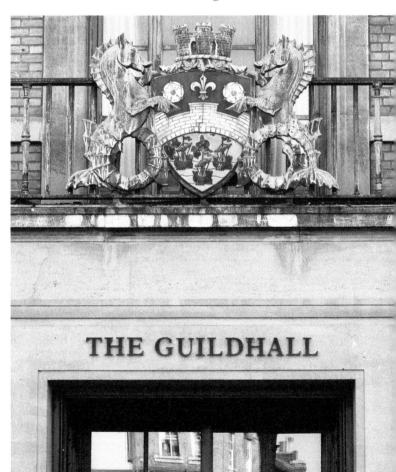

The coat of arms of Cambridge.

only granted to Cambridge in 1575, the borough had received many royal charters before then. The most significant, in terms of economic and administrative power, was in 1207 when King John granted the town the right to elect a reeve – a position which evolved into a mayor – as the official head of the town. Over a century earlier, Henry I had given Cambridge townspeople the right to collect taxes, instead of these going to the Crown. The king had also given the townspeople a monopoly over loading and unloading boats in the county. Finally, in 1256 Henry III freed the town from all administrative control of the Crown.

The University of Cambridge has also benefitted from royal patronage over the centuries. Of course, kings have endowed colleges, most notably King's College (Henrys VI, VII and VIII) and Trinity College (Henry VIII). In more modern times, many future kings have been educated at the university colleges. In 1861, the future Edward VII was sent by his parents, Victoria and Albert, to read history at Trinity College. The King Edward VII Professorship in English Literature is one of the senior such posts at the university, founded in 1910 by Sir Harold Harmsworth, 1st Viscount Rothermere, in memory of the king who had died earlier that year. Edward then ensured that his own son and heir, Albert Victor, attended Cambridge. Sadly, Albert Victor died of flu at the age of twenty-eight and therefore never acceded to the throne of England. Another royal alumnus of Trinity College was George VI and he was followed by his grandson, Charles, Prince of Wales, who graduated in 1970 with a second-class honours degree in anthropology, archaeology and history, the first heir apparent to earn a university degree.

King's College was endowed by no fewer than three kings.

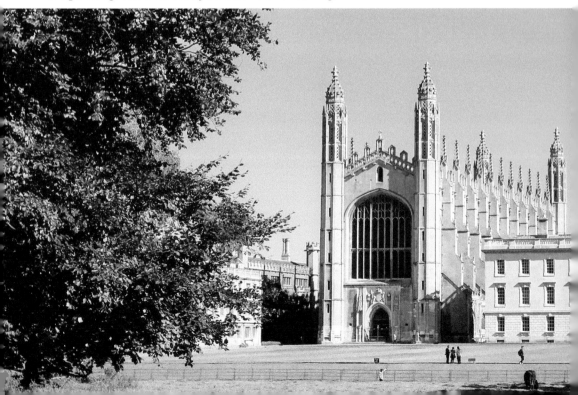

L

Lines

In 1822, a first survey was undertaken to open up a railway line running to Cambridge, although it took until 1845 for a main line to be built from the East End of London to Cambridge. It was laid by the Eastern Counties Railway and, on the insistence of the university, the station was constructed some distance from the town centre – the authorities feared that the noise would distract their students. This first station building soon became too small and was rebuilt in 1863. By this time, the Great Eastern Railway was running the lines through Cambridge.

Cambridge residents, especially tradesmen, immediately reaped the benefits from the coming of the railway. Some, though, were not so happy. One stagecoach company

Shields of the university's colleges adorn the Victorian railway station.

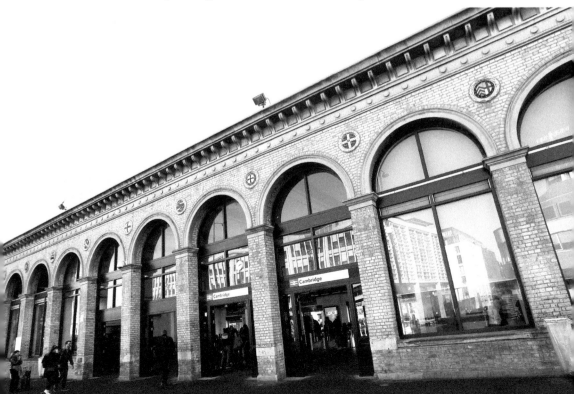

had to sell 500 horses within two weeks of the railway's opening and four years later stagecoaches ceased their operations from Cambridge to London altogether. This traditional horse-drawn transport simply could not compete with the cheap and quick rail travel: it usually took two days to reach London by stagecoach as opposed to 1 hour 50 minutes for first- and second-class passengers, although those who could only afford third class could only take the daily slower train, taking 4 hours.

The Foster brothers owned three riverside mills in Cambridge in the second half of the nineteenth century and therefore campaigned to have the railway extended to the river. However, yet again, the university blocked the proposal and so, in 1898, the Fosters constructed a flour mill adjacent to the railway station. Although now residential apartments, the mill is one of the largest buildings in the city. The family had also founded Fosters' Bank for use by their mill workers earlier in the century, commissioning a new building in Sidney Street designed by Alfred Waterhouse, most famous for his design of the Natural History Museum in London.

At around 470 metres long, the railway platform at Cambridge is now the third longest in the United Kingdom. The novelist Kingsley Amis spent two years as a Fellow at Peterhouse, Cambridge, which was not altogether a happy experience. He found the university an academic and social disappointment and had harsh words to say about the platform: 'that curious railway station, with its endless single platform like something out of Kafka or Chirico'.

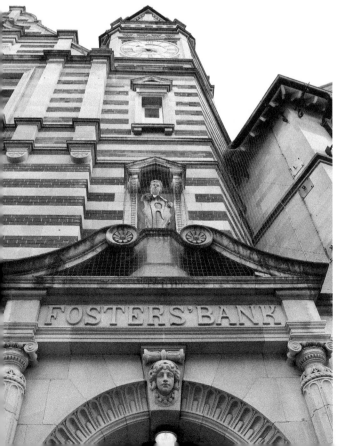

The Foster family bank designed by Alfred Waterhouse.

M

Mayors

The office of Mayor of Cambridge is now over 800 years old and, although it is now a largely ceremonial role, it once carried much more authority. It was therefore a sought-after position by prominent merchants and businessmen. The first recorded mayor was Hervey Fitz Eustace in 1213, who lived in a house now called the School of Pythagoras which still stands today in the grounds of St John's College. Remarkably, it took over 700 years before a woman was elected to the role when Eva Hartree became the first Lady Mayor of Cambridge in 1924. In 1971, Jean Barker was one of her successors. Barker later became Baroness Trumpington, taking her title from the area she had represented on the City Council for fourteen years. However, the peer was clearly not enamoured of her role as mayor, describing it as 'folderol', meaning nonsense!

Reach Fair is an annual event in the mayoral calendar, and it has been the duty of the Mayor of Cambridge, since 1201, to officially open this annual event in the village

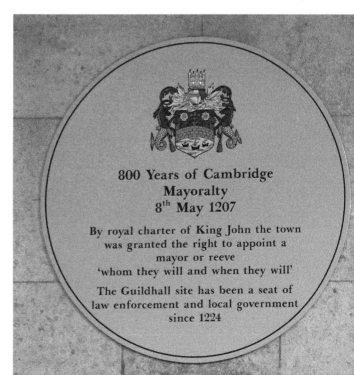

A plaque inside the Guildhall celebrating the office of mayor.

800 Years of Cambridge Mayoralty 8th May 1207

By royal charter of King John the town was granted the right to appoint a mayor or reeve 'whom they will and when they will'

The Guildhall site has been a seat of law enforcement and local government since 1224

of Reach. The mayor also attends and opens the Midsummer Fair, held on Midsummer Common. This common, together with Parker's Piece, was the focus of huge celebrations to mark the coronation of Queen Victoria in 1838. A curious set of entertainments and contests was staged, including bobbing for oranges in a trough, a grinning match (more commonly known as a gurning competition nowadays) and biscuit bolting, which involved twelve boys eating a pennyworth of biscuits each with the first to eat his supply winning a waistcoat! The coronation celebrations included Cambridge's biggest feast ever, which was presided over by Mayor Charles Humfrey. Some 7,000 joints of meat, 4,000 loaves of bread and 1,650 plum puddings were prepared for the banquet for the townspeople.

Charles Humfrey was an architect by profession, as well as a local property owner. He had designed many houses and terraces in and around the town, mostly in Cambridge white brick. In the 1820s, he had built himself a mansion, Clarendon House, near to Parker's Piece. Humfrey also constructed a row of terraced houses in Orchard Street for his servants to live in. However, they were built without any first-floor windows at the front of the properties so the occupants could not look over his garden wall!

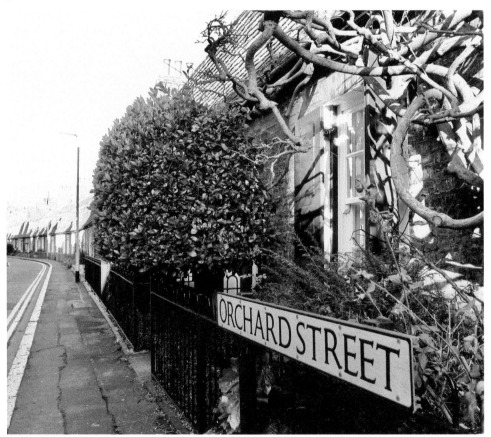

Charles Humfrey's employees were not able to overlook his garden.

The Orchard Street houses only have first-floor windows at the rear.

Merchandise

There has been a market on Market Hill since Saxon times, and it is still thriving today. Before the nineteenth century, Cambridge's marketplace was L-shaped and was surrounded by timber buildings, including a guildhall and a prison. The marketplace also housed a fountain, a cross, as well as the stocks and pillory where petty criminals were punished and humiliated. Corn, poultry and butter were sold on the north side of the markets, vegetables in the centre and milk to the west of the market cross. A guidebook of 1814 says that the market of Cambridge were 'supplied in the most abundant manner with every article of provision: the quantities that are exposed for sale are sometimes astonishing, and its quality is in general excellent'.

Petty Cury is one of the very early street names to survive to this day. Its name literally means 'little cookery' as it was once a main thoroughfare lined with pastry cooks' stalls. It was probably known as the small cookery because there was a main Cook's Row on Market Hill.

Many more of the street names in and around the market area have long since disappeared. These include Butcher Street, which is the present-day Guildhall Street, Short Butcher Row, now called Wheeler Street, and Slaughter House Lane, the old name for Corn Exchange Street. All these streets were in the medieval Shambles, which was a term used for an open-air slaughterhouse and meat market. The animal hides were even sold on to traders in Shoemaker Row who turned them into all manner of leather goods.

In 1579, a ruling was made concerning the fish market: 'all fresh-water and sea fish brought to the town and all the common fishmongers which usually have stood in the market over against the new shambles shall from henceforth be sold on the Pease Market Hill and have their standing there'. It is possible that this area had been used by fishmongers before this time as the name Peas Hill may come from the Latin *pisces* for fish. Peas Hill remained the main place for the sale of fresh fish until 1949.

Twenty-first-century fast food at the market.

Today's market stalls stand on the site of their Anglo-Saxon predecessors.

The market area suffered a disastrous fire in 1849 which destroyed many of the old wooden buildings. The remaining houses were demolished and part of the churchyard of Great St Mary's cleared to make way for a new, square Market Hill.

Miles

It was the Romans who first instituted a system of milestones in Britain, so they could track their progress on the Imperial roads they had constructed. Of course, these stones no longer adorn our highways, but it is claimed that Great St Mary's Church in Cambridge marks the start of a row of milestones which were the first to be erected in the country since the fall of the Roman Empire.

In the eighteenth century, road travel was becoming vital for industry and communications, and several road maps had been published which gave accurate distances between landmarks and towns. As one of the prominent provincial towns, Cambridge had good, fast (or at least for the time!) road links to London, and so in the early 1700s, William Warren set about constructing some new milestones. Warren was a trustee of the Walpole Trust, which was administered by Trinity Hall. The trust was responsible for the upkeep of the highways in and around Cambridge, and Warren had begun to survey the coach road to London in 1725, armed with nothing but a 66-foot surveyor's chain.

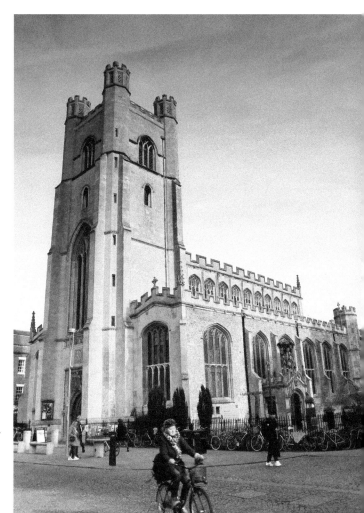

Great St Mary's was William Warren's choice as the centre of Cambridge.

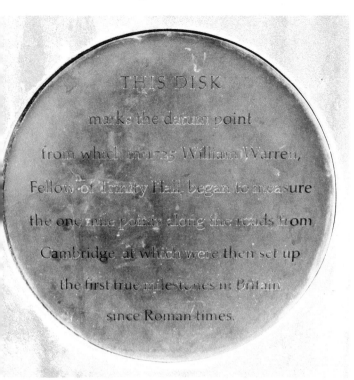

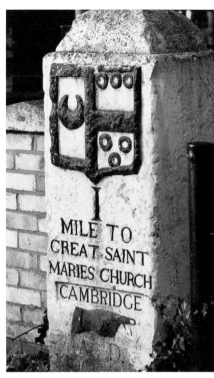

Above left: A plaque at the foot of Great St Mary's tower.

Above right: The first of William Warren's milestones on Trumpington Road.

With money from the trust fund, William Warren set up a series of sixteen milestones. The road was measured from the south-west buttress of the tower of Great St Mary's and the last of Warren's milestones was outside the Angel Inn at Barkway, Hertfordshire. His first milestone, which lies at one end of Brooklands Avenue, cost 5 pounds 8 shillings. Apparently unsatisfied with his first set of milestones, Dr Warren replaced them over the period 1728 to 1732. Most of the milestones on this route are decorated with the crescent arms of Trinity Hall.

In June 1940, with Britain at war with Germany, the government decreed that all place names should be hidden or removed, to impede the enemy in case of invasion. Warren's milestones were therefore laid down and hidden in the verges. They were re-erected in 1946 where many of them can still be seen today.

To celebrate the opening of some new college buildings in 2006, Trinity Hall commissioned a stone in the style of William Warren's pioneering milestones. The first of two pointing hands on it indicates 2,006 metres in the direction of the centre of Cambridge and the other hand tells us that the milestone is 50 metres from the college entrance.

N

Notes

The one image conjured up in most people's minds when they think of Cambridge and music is the Service of Nine Lessons and Carols from King's College, now broadcast around the world on radio and television on Christmas Eve. It represents a long tradition of music-making, both sacred and secular, in the city. The first-known recipient of a Bachelor of Music degree at the University of Cambridge was Henry Abyngdon, Master of the Children of the Chapel Royal to Edward IV, in 1464.

For over 300 years, the town of Cambridge employed its own musical band. These musicians, originally called waits, were at first employed to sound the hours during the night. Later they were in demand to provide entertainment for civic and university pageants, plays, ceremonies and celebrations. First formed in the late 1400s, they played all manner of instruments unfamiliar to concert-going audiences today, such as viols, shawms, sackbuts and cornets. The band had their own livery comprising cloaks, silver collars and chains and a silver band. In the sixteenth century, the waits were led by William Gibbons and his son, Orlando, who joined the choir of King's College in 1596, eventually becoming one of the foremost composers of the age. Later, when Cambridge alumnus Samuel Pepys visited Cambridge in October 1667 he recorded 'The town musique did also come and play, but, Lord, what sad music they made! However, I was pleased with them, being all of us in very good humour.'

A visitor to Cambridge cannot fail to notice the hundreds of posters for concerts, as well as other events, affixed to the railings around the city centre. They advertise a wide range of concerts from regular lunchtime recitals in several churches, large rock concerts in the Corn Exchange, and live bands in numerous pubs in the area. Some of these are the successors of the university concert-giving societies which met in rooms in local inns such as the Red Lion and the Black Bear.

Despite a long history of music at the university, the first Faculty of Music was only established in 1947. Since then the number of music students has increased enormously and musical activity of every kind has flourished. The Faculty now occupies the purpose-built University Music School and Concert Hall in West Road, built in the 1970s and boasting excellent acoustics.

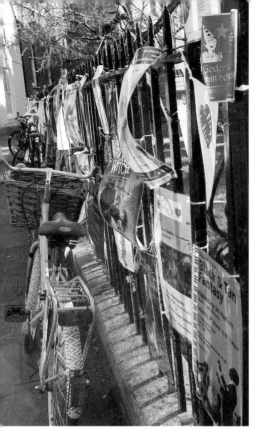

Left: Concert posters on the railings in All Saint's Passage.

Below: Concert-goers at the West Road Concert Hall.

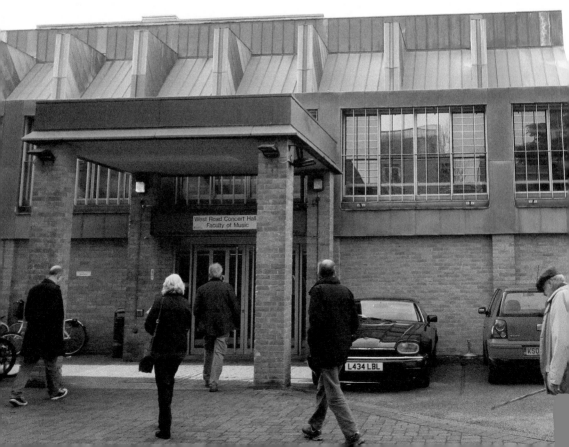

O

Oars

The University of Cambridge is almost as well known for its rowing as it is for its academic achievements. The boat race against the University of Oxford was first run in 1829 on the River Thames at Henley, moving to London in 1856 when it started as an annual event. The Champion of the Thames may seem an unlikely name for a pub in Cambridge, as this river flows nowhere near the city. It derives its name from an oarsman who won a race on the Thames before moving to Cambridge in 1860. The rower lodged at a house in King Street and asked for all mail to him to be addressed to 'The Champion of the River Thames, King Street, Cambridge'. The house later became a pub and took on this unusual name.

The so-called Bumps are Cambridge's inter-college equivalent of the famous boat race, although the rules are rather different. The first Bumps race was held in 1827 on

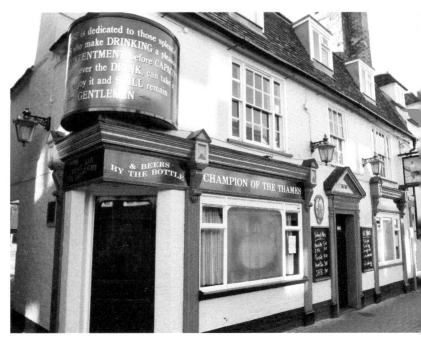

The curiously named Champion of the Thames pub.

the Cam in the centre of town. Earlier boats were broader than their modern-day equivalents, and the Cam much narrower and winding. So, instead of crews competing side-by-side, they devised a competition whereby the boats line up one after another and chase each other down the course. When one team catches another boat, they bump or touch the boat. The bumped boat then has to pull over to let the other crew through. Since 1887, the Bumps have been run every Lent (end of February or the beginning of March) and in May.

Left: The university and college boathouses line the River Cam.

Below: Coxless fours training on the Cam are a familiar sight.

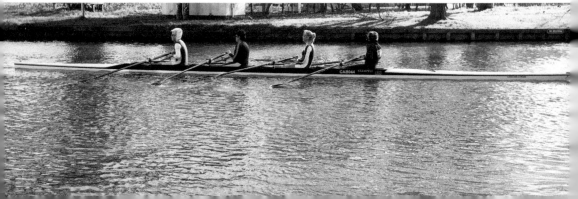

Although today's Bumps are taken seriously, they are not usually dangerous. In the past, however, the occasion has proved fatal for both competitors and spectators. In 1888, a team from Trinity Hall was bumped by a boat crewed by students from Emmanuel College. Such was the momentum of the Trinity Hall boat, it crashed into a Clare College team, injuring one of the crew in the chest. Despite frantic attempts to save him, the rower died within minutes. In 1892, an undergraduate called Lovett was struck dead by lightning whilst walking to the May Bumps and in 1905, a ferry carrying spectators back to central Cambridge after the races capsized, throwing twenty or so people out of the boat. Sadly, three ladies drowned.

Oysters

The legacy of an ancient fair is to be found in several street names just off Newmarket Road in Cambridge. Such names as Oyster Row, Garlic Row, Cheddars Lane and Mercers Row all serve as a reminder of what the writer Daniel Defoe once described as 'not only the greatest in the whole nation, but in the world'. The fair began in the twelfth century and, in 1211, King John granted a charter to the Leper Hospital of St Mary Magdalene, allowing it to hold a three-day market on Stourbridge Common to raise funds for its charitable work with the sick. When the hospital was closed, the town of Cambridge took over the rights to hold the fair, which eventually ceased in 1933.

Over the centuries, the Stourbridge Fair grew dramatically in size, at its peak lasting a whole month. It attracted trade from all over Europe, goods such as wine from France, silks from Italy and furs from the Baltic, which would be unloaded from seagoing vessels in King's Lynn, then transported by smaller boats along the Ouse and Cam rivers. Defoe described the scene on the common: 'The shops are placed in rows like streets, and here are all sorts of trades, who sell by retail, and who come principally from London with their goods; scarce any trades are omitted - goldsmiths,

Echoes of the once great Stourbridge Fair.

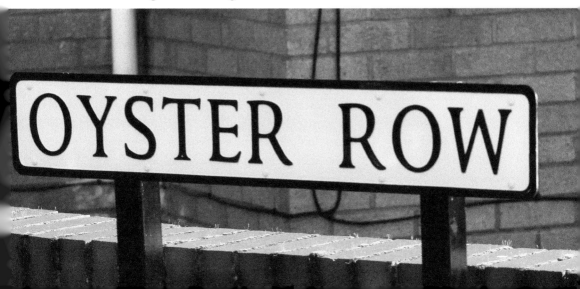

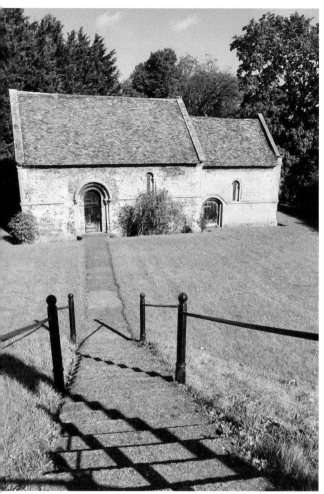

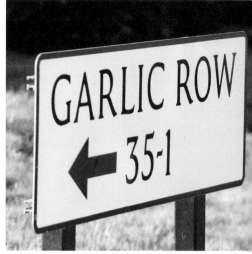

Above: Garlic Row was the main thoroughfare through the fair.

Left: The surviving chapel of the Leper Hospital.

toyshops, brasiers, turners, milliners, haberdashers, hatters, mercers, drapers, pewterers, china-warehouses, and in a word all trades that can be named in London; with coffee-houses, taverns, brandy-shops, and eating-houses, innumerable, and all in tents, and booths.' The fair also provided inspiration for John Bunyan's Vanity Fair in his *Pilgrim's Progress*, writing 'At all times are seen there jugglers, cheats, games, fools, apes, knaves and rogues.'

Today, all that is left of the Leper Hospital is a tiny but beautiful chapel which dates from around 1125. It is thought to be the oldest complete building in the city. By the eighteenth century it had ceased to be a place of worship and was used to store stalls between fairs. In 1783, it was even advertised for sale as a store shed! After changing hands several more times, the chapel was gifted to the university who, in 1951, gave it to the Cambridge Preservation Society, a charity dedicated to protecting and enhancing the city's architectural and natural heritage, later changing its name to Cambridge Past, Present & Future.

P

Priors

It was not long after the Norman Conquest of Britain that monastic communities were founded in Cambridge. Of these, Barnwell Priory grew into the richest and largest in the town. It had been founded in 1092 in the Church of St Giles near the castle and then moved to a site further out of the centre some twenty years later. Here, the monks constructed an extensive range of buildings, including a church, two chapels, a library, refectory, guest hall, infirmary, granary, stables, bakery, brewhouse and gatehouse. With these superb facilities housing thirty monks and their staff at its peak, it gained a reputation as more comfortable lodgings than the castle. Successive monarchs stayed there: King John, Edward I, Edward II and Henry II. In 1388, Richard II and his entire court lodged at the priory whilst holding a session of Parliament in Cambridge.

Although the Barnwell Priory inhabitants were popular with the nobility and royalty, when it came to ordinary townspeople, they fared less well. In June 1381, at the height of the national movement called the Peasants' Revolt, a mob of locals attacked the priory, angry at the monks' use of common land for farming. More than 1,000 people broke into the priory's precincts, pulling down walls and felling trees. They also raided the monks' storehouse for food, including sought-after commodities like fish.

Barnwell Priory survived this riot but finally met its end in 1538 during Henry VIII's closure of all religious houses in England and Wales. The priory buildings were largely dismantled, and the stone used for the new chapel of Corpus Christi College. The church furniture and fittings were sold off, including the alabaster altars, organs, a clock, lamps, candlesticks, bells and choir stalls, as well as the timber and ironwork.

Apart from the priory's Church of St Andrew the Less, the only surviving complete building is that which is thought to have been the Cellarer's Chequer. The Cellarer was the second most important monk in the priory after the Prior. He was responsible for sourcing all provisions for the community and supervising the kitchen and refectory. The Chequer was where the Cellarer conducted his business and this building still retains its thirteenth-century doorway, vaulted ceiling supported by a central pillar, several windows and a fireplace.

Above: St Andrew the Less was built as Barnwell Priory's church.

Below: The Cellarer's Chequer in Beche Road.

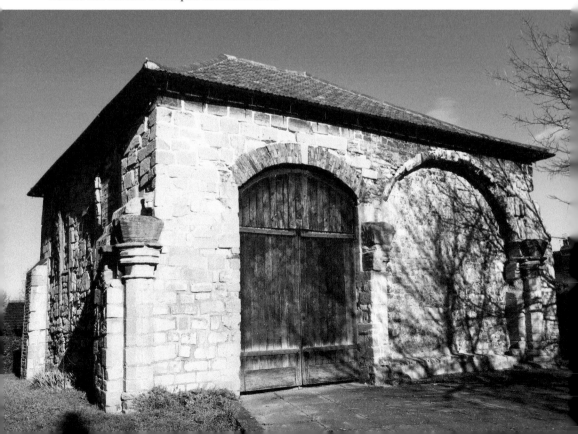

Pulpits

Tucked away behind King's Parade is a small church dedicated to St Edward, King and Martyr. Whilst the rather understated exterior gives nothing away of its major role in the religious life of the country, its interior tells a different story. The account starts not far from the church, in Trumpington Street, where, in the early 1520s, a small group started to meet to discuss the radical ideas of the German monk Martin Luther. These reformers met in the White Horse Inn, which has long since disappeared. Here, Robert Barnes, the head of a nearby friary, Thomas Bilney of Trinity Hall, Hugh Latimer of Clare College and others studied and discussed Lutheran calls to do away with the excesses of the Catholic Church and, instead, to form a simpler Christian faith – Protestantism. Because of these secret meetings in the White Horse Inn, it became known as 'Little Germany'.

The site of 'Little Germany'.

Until 1529 and Henry VIII's break with Rome, England was a Catholic nation. The monarch, therefore, sought to subdue any attempts to reform the church. In May 1521, the university authorities in Cambridge were ordered to confiscate and destroy any 'heretical' books by Luther. They were thrown onto a large fire outside the doors of Great St Mary's Church.

The Protestant reformers' discussions in 'Little Germany' moved to the wooden pulpit in St Edward's Church. The church was, and is, outside the authority of the Bishop of Ely, and so it became the scene of many sermons devoted to attacks on the Catholic Church. At the midnight mass on Christmas Eve 1525, Robert Barnes gave what is believed to be the first openly evangelical sermon in any English church. Over the next decade, many of the great reformers preached at St Edward's.

Cambridge can also lay claim to England's first Protestant archbishop. Thomas Cranmer entered Jesus College in 1503 at the age of fourteen. The college had been founded seven years earlier, providing for a Master, five Fellows, four youths, four boys, a schoolmaster and five servants. He was briefly thrown out of Jesus for marrying a niece of the landlady at a nearby inn but was reinstated when his wife died in childbirth. Later, as college Fellow and having taken holy orders, Cranmer rose to fame as the man who found Henry VIII a way out of his marriage to the Catholic Catherine of Aragon, allowing the king to marry Anne Boleyn. This led to Henry declaring himself as the head of the Church of England, promoting Thomas Cranmer to Archbishop of Canterbury.

England's first Protestant archbishop studied at Jesus College.

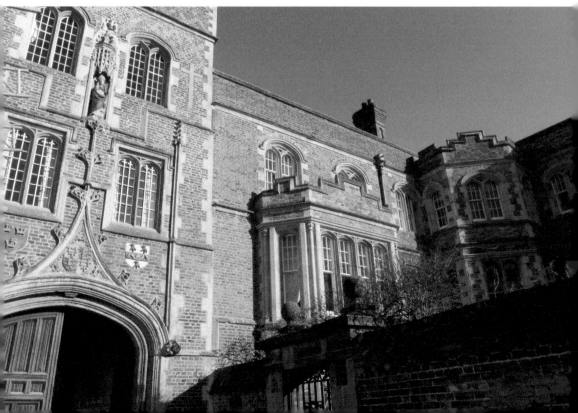

Q

Quay

Magdalene Bridge, formerly known as the Great Bridge, stands near the site of a wooden bridge across the river, which gave the city its name. Some of the very early names for the settlement are lost in the mists of time, although we know that in the seventh century, it was called *Grantacaestir, caestir* referring to the Roman fort then on Castle Hill and *Granta* meaning muddy river. In the following century, the town became known as *Grantabrycge, brycge* being the Anglo-Saxon for bridge. This demonstrated that by then the bridge, rather than the fortification, was the most important feature in the community. From there, the name was further refined to *Cambrigge* and then by 1600, the name Cambridge was commonly used.

The first stone bridge built over the River Cam at this point was constructed in 1754 but it was not long before it was reported to be in a poor state of repair, due in part to the impact of the climate including the regular freezing of the river. Therefore, in 1822, an appeal for public subscriptions was made, to raise the necessary funds – some £2,350 – for a new iron bridge. The following year, the *Cambridge Chronicle* reported, 'We congratulate the public on the completion of the Iron Bridge, which was finished on Saturday last, being within few days of the time stipulated. The general appearance of the bridge, the style of which is Gothic, is exceedingly elegant.' This bridge is the one we see today.

In the early twelfth century, Henry I issued a writ making Cambridge the main port in the county, meaning that it had a monopoly of local river trade at the expense of other towns further downstream. Much of the local produce, including fish, eels, sedge (a thick grass used for thatching) and cereal crops was traded here. The main commercial area of medieval Cambridge was the Quayside, either side of the Great Bridge. Quays extended all the way down the river to the other end of the Backs at Mill Pool. These quays or hythes often took their names from the goods unloaded and loaded at them, such as Corn Hythe and Flax Hythe. Nearby Portugal Place is named for the fortified wine imported to the town.

When the various colleges expanded in the fifteenth and sixteenth centuries, nearly all the quays disappeared, apart from those at the Quayside near the bridge and those at Mill Pool where the corn was ground into flour. Near here, three main mills competed for business: Bishop's Mill, King's Mill and Newnham Mill.

Above left: Quayside was once the commercial centre of Cambridge.

Above right: Picture-perfect Portugal Place.

Below: The former Newnham Mill and millpond.

Queens

Not surprisingly, Queens' College was founded by not one but two queens, hence the placing of the apostrophe! It was the first college to be purpose-built and followed a simple design with hall, kitchens, library, chapel and accommodation all arranged around a small, square courtyard. Margaret of Anjou, the original founder of the college, was the wife of the Lancastrian Henry VI. She issued a charter in 1448 establishing the Queen's College of St Margaret and St Bernard. Interestingly, the second founder was Elizabeth Woodville, wife of Edward IV, a Yorkist. Therefore, both sides in the Wars of the Roses lent support to the same college.

Another key figure in the Wars of the Roses was Lady Margaret Beaufort, the mother of Henry VII and an influential female figure in the House of Tudor. Margaret Beaufort is credited with the establishment of two Cambridge colleges, founding Christ's College in 1505 and beginning the development of St John's, which was completed after her death by her executors in 1511. St John's College lies on the site of a medieval monastic house, the Hospital of St John. Originally, academic study there focused chiefly on the liberal arts, theology and the biblical languages, then gradually

The old chapel at Queens' College.

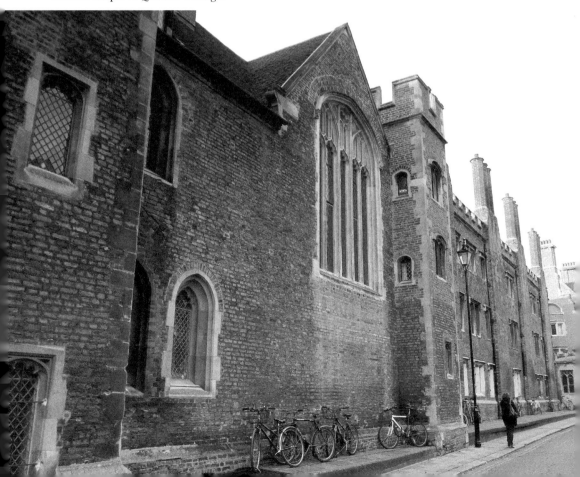

becoming a centre for the study of classics and mathematics. In the twentieth century, it introduced other subjects in the humanities, medicine and the sciences. St John's was, like Queens', constructed around a central court. By 1545, there were 152 Fellows and scholars in the college and further expansion in successive centuries has created one of the largest of today's Cambridge colleges.

Lady Margaret Beaufort's great-granddaughter, Elizabeth I, took a great personal interest in Cambridge, visiting the town for five days in 1564. Preparations for one of these royal progresses was intense for the weeks and months leading up to the visit. The university's vice-chancellor and the town's mayor jointly ensured that the streets were well paved. The Corporation mace was re-gilded, the market cross repaired and even the gallows were mended! The queen stayed at King's College with all fourteen colleges accommodating her large entourage of courtiers and servants. On her arrival into Cambridge, along Silver Street, Elizabeth was 'dressed in a gown of black velvet and a hat that was spangled with gold, and a bush of feathers'. During her stay, the monarch was treated to all manner of plays, feasts, sermons and entertainments, and the town was drunk dry!

Silver Street where Elizabeth I triumphantly entered Cambridge in 1564.

R

Rodents

In 1348, a deadly disease spread from the Continent and hit the southern half of Britain. Like many other towns and villages, Cambridge was helpless to stop the spread of the so-called Black Death into their community. The following year, it reached Cambridge and further outbreaks followed in 1361 and 1369, resulting in the deaths of around a third of the town's population. With its rat-infested houses and poor sanitation, Cambridge townspeople together with the developing university were hit hard. The Black Death was passed on to humans by rats who had been bitten by fleas carrying the disease. It is believed that both Midsummer Common and Coldham's Common were used as mass burial sites for the plague victims. Priests, who tended to the sick and who buried the dead, were struck down in great numbers, so much so that it is believed that Bishop Bateman founded Trinity Hall in order to train clergymen (and lawyers) following the Black Death.

Cows on Midsummer Common are oblivious to the plague victims buried beneath.

When the plague struck Cambridge again in the 1660s, a total of 920 people were recorded as having died, and another 400 or so recovered from the disease. Those who showed symptoms of the plague were shut up in Pest Houses to isolate them from the healthy population, which helped stem the spread of the deadly plague. Again, Midsummer Common was a convenient burial site for many of the victims. During outbreaks of this epidemic, the university was closed, and the students sent home.

One of the latest statues to appear in the city of Cambridge sits at the end of Petty Cury, where the road meets Market Hill. It was unveiled in August 2012 and its most prominent feature is a white cat sitting on top of a top hat, where mice run circuits around the rim. These are also the most recognisable parts of the sculpture, since the main subject, a rather eccentric man called Walter 'Snowy' Farr, is far more difficult to make out. That said, anyone who had ever seen Snowy over the years, standing on that spot outside the Guildhall collecting money for charity, will see the familiar colours of the antique military clothing he used to wear.

Over several decades before his death in 2007, Snowy Farr tirelessly fundraised in aid of various local charities, including the Cambridgeshire Society of the Blind and Partially Sighted, Guide Dogs for the Blind and Cam Sight, which supports people with sight loss in and around Cambridge.

Busking in front of the colourful sculpture dedicated to Snowy Farr.

In September 1977, Snowy Farr led a procession of 150 children on bicycles around Cambridge city centre, filming for a television show which was never aired. He was attempting to recreate the legend of the Pied Piper of Hamelin, who rid the German town of plague-ridden rats and then, because he was refused payment, led all the children away. However, Snowy's escapade did not go according to plan: some of his cats fell off the trailer to his bicycle, energetic children overtook him on their bikes and he even took a wrong turn!

Roundheads

Undoubtedly one of Cambridge's most famous past Members of Parliament was Oliver Cromwell. It was inevitable, then, that when the English Civil Wars raged in the mid-seventeenth century, Cambridge became the headquarters for the Roundheads, also known as the Parliamentarians. The other great seat of learning, Oxford, was the stronghold of the other side in the conflict, the Cavaliers or Royalists, supporters of the king, Charles I.

Oliver Cromwell had spent one year as a student at Sidney Sussex College, Cambridge, and as the town's parliamentary representative, he made it the headquarters for the Eastern Association, his rebel organisation. Cromwell, however, found that the heads of many of the colleges were openly Royalist. A small number were arrested by the Roundheads and imprisoned in the Tower of London; by 1643, a total of eleven heads of colleges had been forced to leave their positions. Cromwell's troops rebuilt Cambridge castle and dismantled the wooden bridges spanning the River Cam to make the town more secure. They also dug ditches to defend their positions. In 1649,

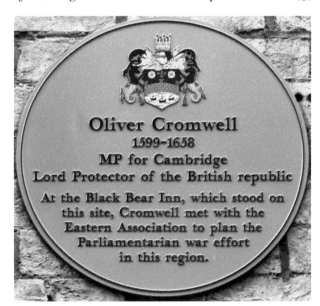

The site of the Black Bear Inn in Market Passage.

Cromwell and his forces were finally victorious. They beheaded the king and declared a Commonwealth of England, ruled by parliament rather than by a monarchy, and Oliver Cromwell became the self-styled Lord Protector until his death in 1658.

After the restoration of Charles II in 1660, the king ordered a posthumous execution at Tyburn in London of Oliver Cromwell, the man who had been responsible for the beheading of his father. After hanging, Cromwell was beheaded, and his head placed on a 20-foot spike above Westminster Hall. Sometime later that century, a storm broke the pole and the head ended up in the hands of a succession of private collectors and museum owners until, in 1815, it ended up in the care of the Wilkinson family. There it remained until one family member decided to organise a proper burial for the embalmed head and so he contacted Sidney Sussex College, Cromwell's former college. It was interred on 25 March 1960, in a secret location near the chapel, preserved in the oak box in which the Wilkinson family had kept the head. The box was placed into an airtight container and buried with only a few witnesses, including family and representatives of the college. The secret burial was not announced until two years later and so the exact whereabouts is not known beyond the few who were present at the ceremony.

Where is Cromwell's head?

S

Stones

The church of Great St Mary's has stood at the heart of Cambridge for over 800 years. It serves a dual purpose, serving their local parishioners and acting as the University Church. In the first few centuries of the church's existence, it burned down more than once, including in 1290, and so a huge rebuilding programme began in 1478. This new church was constructed in the perpendicular Gothic style of the age in fine stonework, in place of the earlier wooden structure. Master mason John Wastell, who created the famous fan-vaulted ceiling in the chapel at King's College, oversaw the works and Henry VII gave 100 oak trees for the beams of the new roof.

A SPEAKINGE STONE
REASON MAY CHAVNCE TO BLAME
BVT DID IT KNOWE
THOSE ASHES HERE DOE LIE
WHICH BROVGHT THE STONES
THAT HIDE THE STEEPLS SHAME
IT WOVLD AFFIRME
THERE WERE NO REASON WHY
STONES SHOVLD NOT SPEAKE
BEFORE THEYR BVILDER DIE
FOR HERE IOHN WARREN
SLEEPS AMONGE THE DEAD
WHO WITH THE CHVRCH
HIS OWNE LIFE FINISHED
ANNO DOMINI 1608
DECEMBER 17

The memorial plaque to one of Great St Mary's churchwardens.

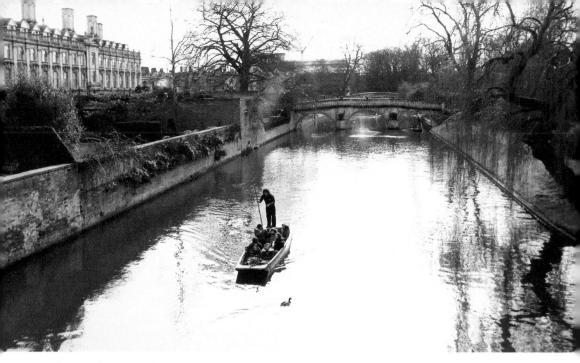

Clare Bridge spans the Cam.

William Gadge, a Fellow at Peterhouse, reported that the first stone of the tower was placed at 'a quarter before seven in the evening' on 16 May 1491. Although the body of the new Great St Mary's was completed by 1519, the tower took another eighty-nine years. A stone inscription bearing the date 1607 inside the staircase of the church tower also bears the initials of the minister, George Watts, and his two churchwardens, John Warren and Marmaduke Frohock. Tragically, John Warren was killed in an accident whilst overseeing the final stages of the building work.

Clare Bridge is the oldest surviving bridge over the River Cam in the city. It was built of stone by Thomas Grumbold and completed in 1640. It is a three-span stone bridge with fourteen stone finials (balls) along the balustrade. Or are there? Those who examine the bridge up close will notice that one of the balls has a small wedge cut out of it, making just thirteen and seven-eighths balls in total. One story to explain this is that two Fellows had a bet as to how many spheres there were on the bridge. Not wanting to lose the bet, one of the men removed part of one of the balls in secret. However, a different explanation is that Grumbold, the mason, left this ball incomplete to express his dissatisfaction at Clare College for not having paid all his fee. Neither may be true at all, since it is possible that this missing chunk merely fell out during repair work and was simply not replaced!

Stretcher

When John Addenbrooke, a doctor and former Fellow of St Catherine's College, Cambridge, died in 1719, he bequeathed £4,500 'to hire, fit up or purchase or erect

This former Addenbrooke's Hospital building is now Cambridge Judge Business School.

a building fit for a small physical hospital in the town of Cambridge for poor people, to be open to every sick poor person of any county, if room and revenue permitted'. Eleven illustrious trustees were appointed to carry out Addenbrooke's wishes and in 1763, they purchased a site in Trumpington Street where they built a hospital. At first it was operated on a small scale and offered only twenty beds, with just one apothecary, a matron and four assistant nurses, three visiting surgeons and three visiting doctors. From 1841, Addenbrooke's Hospital served as a medical school and the premises were gradually enlarged.

At the outbreak of the First World War, there was a mass exodus of students from Cambridge, many joining up to fight on the front line. Those who remained were either medical or science students. By this time, Addenbrooke's had a well-deserved reputation for having well-trained doctors and nurses. So, Cambridge was an obvious choice for a clearing station for casualties of the war. Soldiers suffering from shell shock, shrapnel wounds, trench foot and mustard gas attacks were transported by train to Cambridge, then stretchered to ambulances to take them to hospital. A nurse treating those suffering the effects of mustard gas reported 'Gas burns must be agonising because usually the other cases do not complain even with the worst wounds but gas cases are invariably beyond endurance and they cannot help crying out.'

In 1914, the children's ward at Addenbrooke's was converted into a ward for wounded soldiers. It earned the nickname Tipperary Ward, because of it being relatively inconveniently located on the top floor and, in the words of the popular wartime song,

Above left: Addenbrooke's old outpatients' department is now an exclusive restaurant.

Above right: Cambridge's memorial to its dead of the First World War.

'It's a long way to Tipperary'! Bed space at Addenbrooke's proved insufficient, and so the cloisters of Trinity College provided accommodation for a further 250 wounded servicemen. Later, an open-air hospital comprising prefabricated huts capable of housing 1,000 patients was opened on King's and Clare Cricket Ground. In total, over 62,000 injured soldiers were treated in Cambridge during the war, of whom only 437 died.

In 1951, the gradual process started of constructing a new Addenbrooke's Hospital in Hills Road. In a long, phased approach, it took until 1984 to move all patients out of the old building in Trumpington Street.

T

Town

In Cambridge, the inescapable opposite of town is gown. The rivalry between Cambridge residents and the academic community is sometimes played up and, in the twenty-first century, provides an opportunity for friendly sports matches between the two sides. For instance, an annual fight is staged between men and women of the Cambridge University Amateur Boxing Club and boxers from the city. There is also a traditional fixture between the university students and the Cambridge Rugby Union Football Club. However, over the centuries, this precarious relationship has veered into violence.

Although the nationwide rebellion in 1381, known as the Peasants' Revolt, was essentially an uprising by the labouring class against the government's imposition of crippling taxes, it was used by many as an excuse to demonstrate against wealth and privilege. The University of Cambridge, therefore, found itself in the firing line. A revolt, backed by the Mayor of Cambridge, broke out which resulted in a raid on

Corpus Christi College was founded and then raided by townspeople.

Corpus Christ College, with many books and charters in the library being destroyed by fire. This was a surprising target, given that this college had been founded by townspeople in 1352. On the second day of rioting, the university church of Great St Mary's was robbed of its jewels and vessels, and the university chest in the church broken into and the documents it contained burnt. The townspeople also forced the university and college authorities to sign away their royal privileges. This was subsequently cancelled by the king and the Chancellor of the University was given special powers allowing him to prosecute the criminals and re-establish order in the city. Attempts to reconcile the two factions continued over time, and in the sixteenth century, agreements were signed between the parties aimed at improving the quality of streets and student accommodation around the city.

It is thought that in the 1960s or early 1970s, the name Reality Checkpoint was first given to a large cast-iron lamppost in the centre of Parker's Piece. Nobody knows for sure the reason for the name and there are several theories. The favoured story, however, is that the lamppost marks the boundary between the central university area of Cambridge – the 'reality bubble' – and the real world of the townspeople living beyond.

Below left: Reality Checkpoint in the centre of Parker's Piece.

Below right: A reminder at the base of the Reality Checkpoint.

U

Ugly

As the famous idiom goes, 'beauty is in the eye of the beholder'. This is certainly true of modern art and architecture, the merits of which are endlessly fought over by those with opposing views. It is not surprising, then, that Cambridge has its fair share of new structures which fall into this category.

Founded in 1960, the purpose-built Churchill College, situated in the north-west of the city and occupying over 42 acres, has certainly had its critics. In October 1982, the architectural historian James Lee-Milne noted in his diary of the college architecture 'beastly building, like enormous public lavatory'. Nikolaus Pevsner, famous for his monumental forty-six-volume series of county guides to British architecture, was more ambiguous in his comments recording that the hall is '1960 at its most ruthless'.

Churchill College's architecture still divides opinion.

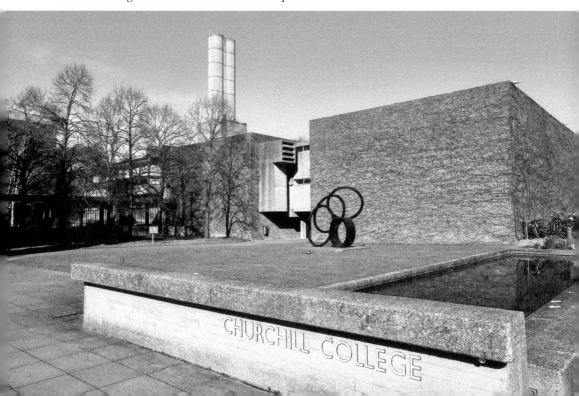

Soon after his resignation as Prime Minister in 1955, Sir Winston Churchill first mooted the idea of founding a new college in Cambridge with a focus on science and technology. His vision was for a college with its emphasis on postgraduate education and on attracting distinguished scholars from around the world. In 1959, on the site of the new college, Churchill said 'I trust and believe that this college, this seed that we have sown, will grow to shelter and nurture generations who may add most notably to the strength and happiness of our people, and to the knowledge and peaceful progress of the world.'

The 1959 competition which brought the college into being was hotly fought by twenty architects and practices, all active in Britain. The winning design was by Richard Sheppard of Robson and Partners, and is of the main college buildings and courtyards arranged around a large central space in which stands the library. The library was extended in the 1970s to include a new Churchill Archives Centre which, today, houses a large collection of papers from a number of leading political figures, including Churchill, Margaret Thatcher and John Major, as well as eminent scientists and engineers.

In the centre of Cambridge stands another ugly – at least to some – structure. Sculpted in 1950 by Michael Ayrton, *Talos* is a depiction of the giant, bronze robot in Greek mythology who was said to protect Crete from pirates and invaders. The statue was erected in 1973 on the completion of the Lion Yard shopping centre. In 2014, *Talos* hit the national press when a swarm of bees settled around the nether regions of the sculpture. It was probably the only time this rather neglected statue received any significant attention!

Possibly the ugliest statue in Cambridge?

V

Virginals

The Fitzwilliam Museum in Cambridge today houses a world-renowned collection of over half a million works of art, manuscripts and historical artefacts. The museum's name comes from its original benefactor, Richard, 7th Viscount Fitzwilliam of Merrion, who had studied at Trinity Hall. Like many other members of the nobility in the 1700s, Viscount Fitzwilliam had undertaken a grand tour of Europe as a young man, during which he acquired a passion for collecting works of art. On his death in 1816, he bequeathed £100,000 and numerous masterpieces by famous European artists to the University of Cambridge. Viscount Fitzwilliam felt strongly that the university should have its own museum, not only to display works of art but also to inform study and education. Thirty-two years later, the new Fitzwilliam Museum opened its doors to students and to members of the public.

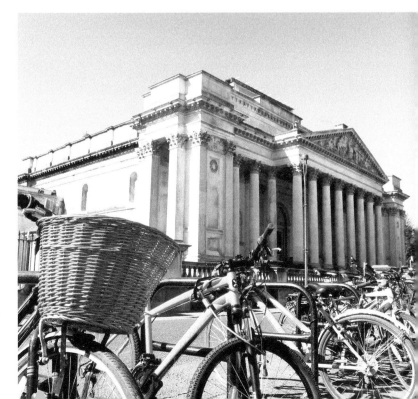

The Fitzwilliam Museum designed by George Basevi.

The Fitzwilliam Virginal Book is among the chief treasures left to the museum by its founder. He had also had a passion for collecting literary and musical manuscripts, which all made their way to the museum. This book is the richest surviving collection of sixteenth- and early seventeenth-century English keyboard music, containing nearly 300 works by the greatest composers of the time, including John Bull, Orlando Gibbons and William Byrd. A virginal (or virginals) was a small, portable keyboard instrument, similar to a harpsichord, which had plucked, metal strings. Indeed, it is thought that it was named for Elizabeth I, the Virgin Queen, who was an accomplished musician on both the virginals and the lute.

It seems fitting that Pembroke College, which lies close to the Fitzwilliam Museum, should have provided the catalyst for the early music revival in the twentieth century. Whilst reading for a master's degree in English at Pembroke in the 1960s, David Munrow became interested in musical instruments of the medieval and Renaissance eras. Together with a Cambridge Professor of Music, Christopher Hogwood, Munrow went on to form the Early Music Consort of London, playing on recorders, crumhorn, virginals, harpsichord, viol and lute. This pioneering group inspired a new generation of enthusiasts for early music and instruments. One of their many recordings, *A Fairie Round* by the English Tudor composer Anthony Holborne, was chosen for inclusion on a pair of phonograph records that were sent into space aboard the Voyager 1 and Voyager 2 space probes in 1977, as a significant example of Western music and representation of human culture.

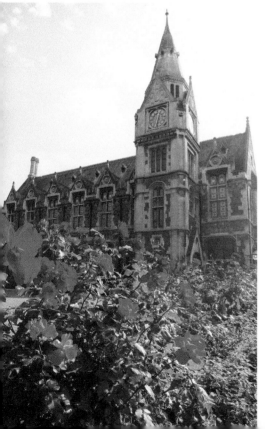

Pembroke College witnessed the early music revival led by David Munrow.

W

Women

In 1869, a woman called Emily Davies established a College for Women at Hitchin in Hertfordshire to take advantage of the fact that the Local Examinations run by the University of Cambridge had finally been opened to females. Four years later, Davies moved her ladies to a new college near Girton, the first residential college for women offering an education at degree level. Since 1976, Girton College has been coeducational, maintaining an equal number of male and female students. In 1871, Anne Jemima Clough, moved her small college for women to Newnham College. Newnham has proudly remained an all-women college to this day. In the early days of these two colleges, there was a degree of rivalry between the principals. Miss Davies considered her college superior to Newnham and championed equality for her ladies. Meanwhile Miss Clough wanted merely to educate her women as teachers, leading Davies to write 'Girton is for ladies, while Newnham is for governesses'.

It then took another eighty years for a third college for women, New Hall (now called Murray Edwards College), to be founded, initially providing places for sixteen students. It still only admits female undergraduates and graduates.

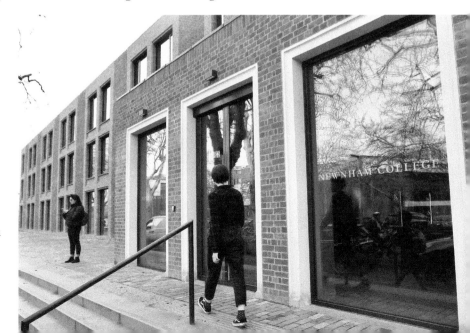

Newnham College remains an all-women college.

The pioneering early female students still encountered difficulties not faced by their male counterparts. Ladies had to be accompanied to lectures by a chaperone and, at first, they were not allowed to cycle, since it was considered an improper activity for ladies. By 1896, Newnham College was finally forced to provide a bicycle shed! In 1899, another Newnham undergraduate recorded 'Our long skirts, stiff collars and tight waists were very uncomfortable and even on the hockey field we were expected to have skirts below the knee.'

Remarkably, it took until 2017 for one of the many university's private clubs, the Pitt Club, to accept women members. The University Pitt Club was established in 1835 in honour of William Pitt the Younger, an alumnus of Pembroke College, and in 1864 moved into the premises it still occupies today. It was originally intended as a political club, but from the start, political events were combined with 'the pleasures of social intercourse at dinner'. The neoclassical building, with stucco porticos and Ionic columns, had been designed and built a few years earlier as Turkish baths, which proved a short-lived venture.

The Pitt Club in Jesus Lane was reluctant to admit women.

Words

Over the centuries, Cambridge has inspired many a writer, but there is one particular area of the city which is immortalised in a number of very different twentieth-century works. Grantchester Meadows is part of the broad green flood plain that runs from Stourbridge Common in the north-east to the village of Grantchester in the south, and it is a regular haunt of bird-watchers and nature lovers.

Having earned a scholarship to study at King's College, Cambridge, Rupert Brooke lodged at the Old Vicarage in Grantchester in 1909–10. Although the village offered Brooke the peace and quiet he needed to complete his dissertation, he also found the beauty of the surroundings a distraction, saying 'the apple blossom and the river and the sunsets have combined to make me relapse into a more than Wordsworthian communion with nature'. Rupert Brooke is now famous the world over for his poems written during the first year of the First World War; he had enlisted on the outbreak of the conflict, serving in the Mediterranean where he died of sepsis in April 1915. It is, however, his 1912 poem 'Old Vicarage Grantchester', written with homesickness while in Berlin, that is probably most often quoted. It is an ode to Cambridgeshire beauty and tranquillity, the last verse beginning:

> Ah God! To see the branches stir
> Across the moon at Grantchester!
> To smell the thrilling-sweet and rotten
> Unforgettable, unforgotten
> River-smell, and hear the breeze
> Sobbing in the little trees.

'Deep meadows yet, for to forget the lies, and truths, and pain?'

The poem ends with the lines:

> Deep meadows yet, for to forget
> The lies, and truths, and pain? ... oh! yet
> Stands the Church clock at ten to three?
> And is there honey still for tea?

The American poet and Pulitzer Prize-winning novelist Sylvia Plath also drew inspiration from the area. Plath obtained a Fulbright Scholarship in 1955 to study at Newnham College, Cambridge where she published her work in the student newspaper *Varsity*. It was at Cambridge that she met her husband and fellow poet Ted Hughes. The couple frequently walked from their house in Eltisley Avenue through the nearby Grantchester Meadows, prompting Plath's poem 'Watercolor of Grantchester Meadows', in which she likens the area to such an idyllic scene that might be found on a child's dinner plate.

'Grantchester Meadows' is also a track on the 1969 album *Ummagumma* by the English rock band Pink Floyd. It was written and performed entirely by the band's singer and bassist, Roger Waters, who was brought up in Cambridge. In the song, a skylark chirps in the background, and a honking goose and incessant buzzing fly (which is subsequently swatted) can be heard.

'Yet stands the Church clock at ten to three?'

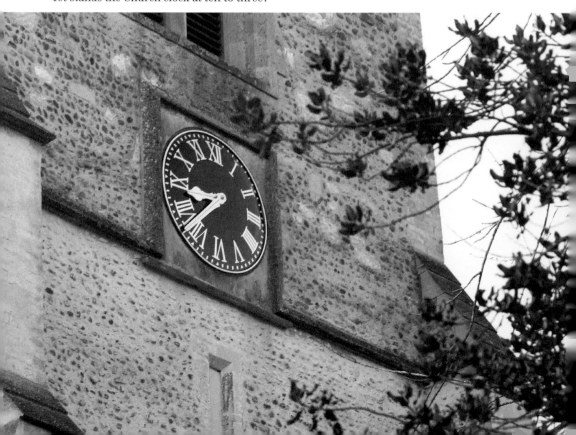

X

X Marks the Spot

The area around Castle Hill, to the north of Magdalene Bridge, marks the spot where the first true settlement of Cambridge lay. It was a perfect site for our Iron Age ancestors to build a densely inhabited village in the first century. It was on high ground, thus avoiding the flooding of the surrounding area but it was near enough to the river and fen to provide much-needed drinking water and building supplies. This large Celtic village, defended only with simple ditches, was swept away by the invading Romans in AD 43 when they established a staging post for their army, close to several of the roads they had constructed which gave them access to all parts of the

Cambridge Castle's motte today.

country roundabout. The invaders reinforced this camp in the face of the threat from Queen Boudica and her Iceni tribe from Norfolk, building a more heavily defended fort. When this military threat was over, the Romans replaced their army camp with a small town.

By the time of the Norman Conquest in 1066, the Saxon town of *Grantabrycge* had extended beyond the Castle Hill area and was bounded by a ditch known as the King's Ditch, constructed by Edward the Elder, son of Alfred the Great. It was a thriving settlement, with a busy marketplace and numerous churches. William the Conqueror lost no time in destroying twenty-seven houses to make way for a large castle to serve as a military base in the region. It would have been a motte-and-bailey style of fortification, of which the most important element was the keep. Possibly just made of timber, the keep was built on a large, steep mound (the motte). The bailey sat at the base of the mound and contained ancillary buildings like the stables, kitchens and accommodation for the soldiers. The bailey was surrounded by a protective ditch and fence.

Cambridge Castle became the home of the first Norman sheriff of the county, Picot. He was a man with a fearsome reputation and was despised by the local Saxons. The monks at nearby Ely described him as 'a hungry lion, a ravening wolf, a filthy hog'.

The first stone castle on this spot was built by Edward I in 1284 but soon fell into ruin. By 1441, the castle's Great Hall was demolished to provide stone for the building of King's College and Trinity College chapel. Further plundering followed in the sixteenth century until nothing remained apart from the ruins of the keep and the gatehouse, which was used as a jail.

Y

Yanks

Links between Cambridge and the United States go back to the founding fathers of America. Of the first 132 graduate emigrants to New England, 100 came from the University of Cambridge, thirty-five of them from the Protestant college of Emmanuel.

In the twentieth century, during both world wars, the Cambridgeshire airfields of Duxford, Bourn and Oakington, among others, became the home of Royal Air Force bomber squadrons and smaller fighter planes. When the United States joined the Allies, some of these airfields became the headquarters for the US Air Force. For instance, the 78th Fighter Group of the United States 8th Army Air Force was stationed at Duxford. In their final mission in April 1945, these US fighters escorted the British bombers which targeted Hitler's mountain hideaway at Berchtesgaden in southern Germany.

American pilots from the nearby airbases filled the pubs of Cambridge and surrounding villages in their time off. In the city centre, the Eagle pub in Bene't Street attracted many Yanks, as well as British servicemen. In a bar at the back of the property, they gathered in a room darkened by blacked-out windows in case of air raids. To while away the time, they started to scorch names and squadron numbers

Airmen's graffiti in The Eagle.

Row upon row of crosses at the Cambridge American Cemetery.

on the ceiling using cigarette lighters and candles. There are also Latin phrases, mottos of the various squadrons and even a faux-Chinese saying 'Ding Hy!', an expression in common usage in the US Air Force meaning The Best! or Number One! It also appears that lipstick, borrowed from barmaids, was also used to draw on the ceiling. One such piece of graffiti is a naked woman smoking a cigarette, apparently modelled on the Eagle's landlady, Ethel!

To commemorate the huge contribution the United States made to the Second World War, and to honour their dead, the University of Cambridge donated a 30-acre plot of land in Madingley, just outside the city centre, to create a burial ground. It was officially opened in June 1944 and contains the remains of 3,811 US servicemen, most of whom died in the Battle of the Atlantic or in the strategic air bombardment of north-west Europe. A long monumental wall records 5,127 names of those who were missing in action.

The United States 8th Army Air Force alone bore over 26,000 casualties during the Second World War and this sacrifice was honoured in 1945 by granting the force the Freedom of the Borough of Cambridge.

The wall bearing the names of those missing in action.

Z

Zoology

One of the most dynamic of the museums in the city is the University Museum of Zoology. It has been on the same site since 1865 but recently underwent a five-year, £4.3 million redevelopment, with assistance from the Heritage Lottery Fund. Its impressive entrance houses the skeleton of a 21-metre-long fin whale, the second largest species on Earth after the blue whale. Its exhibits explore stories of conservation, extinction, survival, evolution and discovery. The revamped museum is designed to engage and inspire a new generation, following in the steps of Charles Darwin and the broadcaster and natural historian Sir David Attenborough.

Attenborough studied geology and zoology at Clare College, Cambridge in the 1940s and in his autobiography, he recalls his student days were 'largely laboratory-based'. He continued, 'We were taught about the anatomy of animals and peered into the entrails of crayfish, dogfish and rats. We sat in lecture theatres while the complexities of animal classification were explained and illustrated with skeletons and stuffed

The striking fin whale skeleton.

skins ... But there was no suggestion that we might ultimately, as qualified zoologists, watch elephants in Africa or crouch in a hide in the depths of a tropical forest watching some rare bird at rest.'

Although the museum today certainly has plenty of skeletons and stuffed animals, it encourages a rather more hands-on approach, especially from its younger visitors. In advance of the 2018 reopening, Sir David Attenborough said, 'This marvellous museum is a place where the public can come to see, study and wonder. The University Museum of Zoology, Cambridge is of the highest importance to the study of zoology and to the understanding of the natural world by people at large. Long may it flourish.'

In 2016, at the opening of the renamed David Attenborough Building, the naturalist abseiled down one of the internal walls which houses both the museum and the Cambridge Conservation Initiative. This institute supports research on biodiversity conservation, including how humans engage with nature. It brings together university academics from various different schools, including geography, zoology, plant sciences and land economy, all intent on ensuring a sustainable environment for life on Earth.

The famous naturalist abseiled down the building named after him.

Select Bibliography

An Inventory of the Historical Monuments in the City of Cambridge (London: HMSO, 1959)

Barrowclough, David, *Cambridge* (Stroud: The History Press, 2013)

Boyd, Stephanie, *The Story of Cambridge* (Cambridge: Cambridge University Press, 2005

Chainey, George, *A Literary History of Cambridge* (Cambridge: Cambridge University Press, 1995)

Chrimes, Nicholas, *Treasure Island in the Fens: The 800-year Story of the University and Town of Cambridge, 1209 to 2009* (Cambridge: Hobsaerie Publications, 2009)

Cooper, Charles Henry, *Annals of Cambridge* (Cambridge: Warwick & Co., 1842-1908)

Defoe, Daniel, *Tour Through the Eastern Counties of England* (London: Cassel & Co., 1888)

Fuller, Thomas, *The History of the University of Cambridge: From the Conquest to the Year 1634* (Cambridge: Cambridge University Press, 1840)

Garrett, Martin, *Cambridge: A Cultural and Literary History* (Oxford: Signal Books, 2004)

Gray, Ronald, and Derek Stubbings *Cambridge Street-Names: Their Origins and Associations* (Cambridge: Cambridge University Press, 2000)

Reeve, F. A., *Cambridge* (London: Batsford, 1976)

Roach, J. P. C. (ed), *A History of the County of Cambridge and the Isle of Ely: Volume 3, the City and University of Cambridge* (London: Oxford University Press, 1959)

www.bbc.co.uk/news

www.cam.ac.uk (including many individual college websites)

www.cambridge.gov.uk

www.cambridgeppf.org

www.capturingcambridge.org

www.creatingmycambridge.com

www.lostcambridge.wordpress.com

www.pepysdiary.com

www.wikipedia.org

Acknowledgements

All the photographs in the book, and on the cover, were taken by my friend Tony Scheuregger, an experienced photographer. They are the result of many fun days spent together walking and touring around Cambridge. Tony also shared his knowledge of, and enthusiasm for, Cambridge with me and I have certainly incorporated many of his ideas into this book. I am also indebted to my husband, Mike, who acted as proofreader and sounding board, as well as chief cook and bottle washer.

About the Author

Sarah Doig was born in Hertfordshire, moving to Suffolk with her family at the age of one. She was brought up and educated in Bury St Edmunds, which she left to attend university. Sarah then found herself away from East Anglia for some twenty-seven years and, after having travelled the world during her twenty-year career in the Foreign and Commonwealth Office, she returned to live in Suffolk. She now works as a freelance local history researcher, writer and speaker. Sarah is the author of several East Anglian local history books including *A–Z of Ipswich*, also published by Amberley. Sarah's website is at www.ancestral-heritage.co.uk.

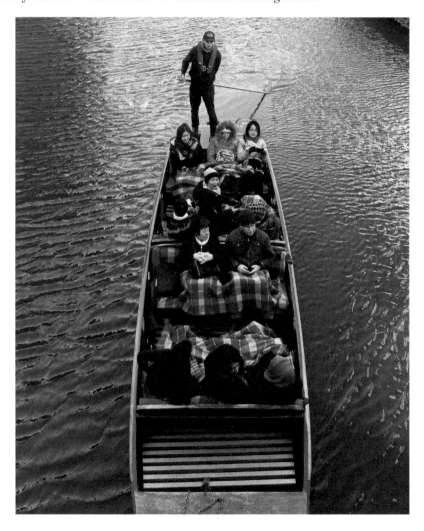